Little Germany

A HISTORY OF BRADFORD'S GERMANS

Susan Duxbury-Neumann

AMBERLEY

With special thanks to Dave West and the Little Germany Action Ltd. Their help with this book has been invaluable and is greatly appreciated.

First published 2015

Amberley Publishing
The Hill, Stroud
Gloucestershire, GL5 4EP

www.amberley-books.com

Copyright © Susan Duxbury-Neumann, 2015

The right of Susan Duxbury-Neumann to be identified as the Author of this work has been asserted in accordance with the Copyrights, Designs and Patents Act 1988.

British Library Cataloguing in Publication Data.
A catalogue record for this book is available from the British Library.

ISBN 978 1 4456 4962 7 (print)
ISBN 978 1 4456 4963 4 (ebook)

Typesetting and Origination by Amberley Publishing.
Printed in Great Britain.

CONTENTS

Chapter 1 Early History of Bradford 5

Chapter 2 The Wool Merchants 19

Chapter 3 German Migration to Bradford 22

Chapter 4 The German Wool Merchants 26

Chapter 5 The Development of Bradford's Little Germany 49

Chapter 6 The Merchant Warehouses of Little Germany 60

Chapter 7 Politics, Trade and the Start of a Long Decline 110
 in the Wool Trade

Chapter 8 The German Pork Butchers 113

Chapter 9 What Happened to the Germans? 116

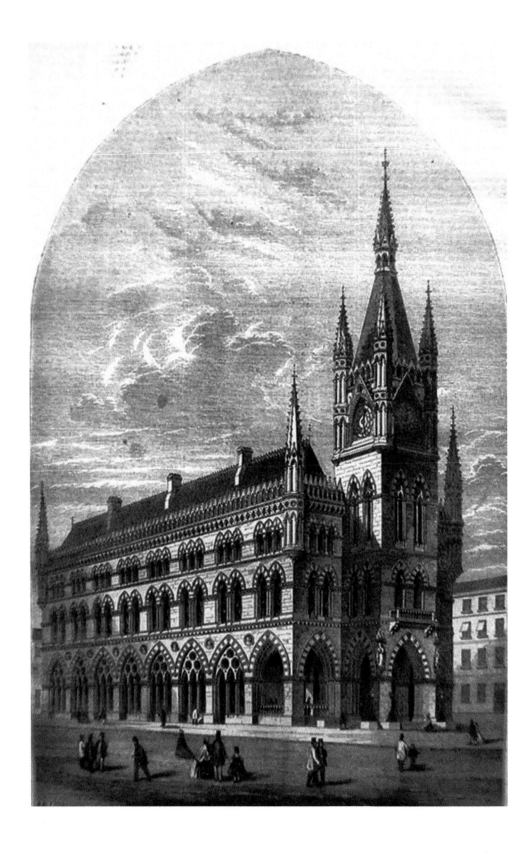

CHAPTER 1

EARLY HISTORY OF BRADFORD

The development of Bradford from a quiet and secluded market town to the wool capital of the world is the result of an ideal environment for sheep farming and the treatment of wool, along with the drastic changes in production brought about by the industrial revolution.

Attracted by this spectacular growth of industry, the Germans became Britain's largest immigrant population for most of the nineteenth century. During the early part of that century a large number of German merchants settled in the Manchester area. Other occupations were musicians, waiters and a large number of sugar bakers who, until the end of the century, played a significant role in this industry as 'boilers'. But by far the most outstanding groups of Germans to settle in Great Britain were the German pork butchers, together with another, but quite different type of immigrant, the stuff or cloth merchant. Many of these merchants were German Jews, already established in their home country but eager to expand and always on the lookout for new markets.

During the Victorian and Edwardian eras, not only a handful of wealthy mill owners such as Sir Titus Salt became generous contributors towards improving the lives of the poor and needy in Bradford's imbalanced society of wealth and poverty, but also this minority of German Jews; some of them wealthy wool merchants and philanthropists, who built their palazzo-style warehouses in the area of Bradford called Little Germany.

At the beginning of the eighteenth century, Bradford's population was around 4,000 inhabitants. Although largely recovered from the Civil War, the town was still impoverished according to Daniel Defoe, the author of *Robinson Crusoe*. In 1720 he wrote in his *A Tour thro' the Whole Island of Great Britain*, describing the poverty of Yorkshire people as having 'scarcely sowed enough corn to feed their poultry'.

Crop growing has never been hugely successful on the high moorland countryside around the Bradford area, which is unsuitable for agriculture, but excellent for sheep-rearing. Within the rolling hills of the Yorkshire Dales, sheep have thrived for centuries; they can be milked (and still are, in many parts of the world); their fleece can be spun and woven into cloth. Man soon realised that to kill the sheep for its meat alone was a waste of food and material, and once he became a shepherd, with the help of his friend the dog – probably the only animal to be domesticated before the sheep – he soon devised a method of producing clothing from fleece. Thus, he had

discovered an incomparable and durable fabric for clothing, which protected from heat and cold, from wind and rain; it kept him cool during the heat of the day and warm during the cold of the night, absorbing moisture without feeling wet. No other material, natural or man-made, has all its qualities. Man can refine and improve wool by the selective breeding of sheep; by incorporating in wool fabrics such qualities as shrink resistance, durable creasing and pleating, mothproofing, shower-proofing and stain-proofing. Science and technology have kept wool in the forefront of fabrics, adapting to modern needs without impairing its virtues. Wool is part of Britain's history and heritage, more so than any other commodity ever produced on these islands.

For thousands of years, wool has been spun and woven into cloth by the tribes of northern Europe. To spin it they took the wool in one hand and drew it out, twisting it into a thread with the fingers of the other hand. The result was a thick uneven yarn. Later, a crude spindle was developed by fitting a stone or clay ring to the end of a short wooden stick. The ring acted as a flywheel and enabled the drawn-out yarn to be wound on to the spindle. This method of spinning has been used for thousands of years and is still used by peasant communities in various parts of the world.

Weaving is the criss-crossing of threads of wool to make cloth. The first loom consisted of a beam from which lengths of yarn (warps) were hung and weighted at the lower end by stones. The 'weft' yarn was threaded to and fro across the suspended 'warp' yarns in an over-and-under action, like darning a sock. As with spinning, this system has also been employed for thousands of years.

There were now two implements: one for spinning, and one for weaving spun wool. The loom was the first to be improved. The warp threads were laid out horizontally across a frame instead of being suspended vertically from a beam. Then alternate warp threads were tied to sticks (healds) which were raised and lowered in turn. Through the aperture formed between the two sets of warp threads, the wooden needle carrying the weft thread could be passed in one motion, thus avoiding the laborious 'over-and-under' action. Later still, the needle was hollowed out into a 'shuttle' so that it could carry within itself a reel of weft thread, as it does in a modern loom.

The spinning-wheel arrived much later between AD 500 and AD 1000, replacing the ring and stick. The wheel was connected by a pulley to the spindle mounted horizontally on a frame. One turn of the big spinning-wheel gave about twenty turns of the spindle, so wool could now be spun more quickly. But the greatest wealth came from exports of raw wool. Kings and their ministers keenly appreciated the revenue that resulted from exports and export taxes, and for the power it gave to the king, who could grant or withdraw concessions to the wool towns and to the industry. Weaver's Trade Guilds, powerful for hundreds of years, were founded to guarantee good work by experienced craftsmen. The 'Staple' – a medieval tax on wool to be exported – was established at a number of ports in England and despite setbacks such as political strife, war and the bubonic plague (Black Death), raw wool exporting expanded, and so also did manufacturing of wool fabrics. This was becoming both specialized and localized.

The West Country had three advantages; extensive sheep pastures, a supply of soft water for washing, scouring and dyeing, and water-power to drive milling machinery.

Similarly, the Pennine districts of Yorkshire and Lancashire had soft water, and steeply-graded streams generated water power.

Cloth from English looms quickly achieved an international reputation. From being primarily a raw wool exporter England became, in the fourteenth and fifteenth centuries, a manufacturer and exporter of cloth. At the end of the fifteenth century, England was largely a nation of sheep farmers and cloth manufacturers. The next two centuries saw continued expansion of the industry, despite conflicts at home and abroad. Also, the skill of British sheep breeders had a widespread effect. New techniques, not only in breeding but also in husbandry, brought a great leap forward. It has taken centuries of selective breeding and cross-breeding to produce the sheep of today. Thus, due partially to the fact that much of the agricultural land in the Bradford area was of an inferior quality, generations of small-holders supplemented their meager incomes by turning raw wool into woven cloth.

Over the centuries, a flourishing cottage industry developed, which would last until the invention of steam-powered engines. Produce was usually sold at the nearest market and people often journeyed for miles across the hills with goods strapped to their backs. In later years, goods to be bought and sold were collected by Wool Staplers and transported by packhorse over narrow Pennine tracks. This formed the basis of the mercantile trade and Wool Staplers (dealers in raw wool) became crucial to this cottage industry. They took over the marketing of wool-products, travelled widely to purchase raw wool and visited the homes of the craftsmen who hand-combed it, spun it into yarn and eventually wove it into cloth. Trade grew rapidly, due to the excellent quality of products, which again was due to the abundance of soft-water. Water is free of lime around this area of West Yorkshire, good for both washing and dyeing but vitally necessary for the optimal treatment of wool. Since the Bronze Age, the wool trade has depended on its deep wells of pure soft water; the most precious in the centre of Bradford was known as 'Jacob's Well' which was located on Halls Ings, close to the Hilton Hotel and the Jacob's Well Pub.[1]

John Hustler, who was born in 1715, belonged to a small group of Quaker businessmen. He was probably the one man whose influence changed Bradford from a village to a large city and took in virtually all the eighteenth-century projects resulting in the Industrial Revolution.

His father was a wool merchant (probably wool stapler) as well as a farmer and John served an apprenticeship as a wool-sorter and stapler. The family business flourished during the 1740s. John Hustler was instrumental in building the Piece Hall which is commemorated by 'Hustlergate', a city-centre street near the original site of the building. The building was completed in 1773, and used for the sale of hand-woven and unfinished worsted 'piece' goods.

Worsted is the name of both a yarn, usually made from wool, and the cloth made from this yarn. The name 'Worsted' derives from Worstead, a village in the English county of Norfolk which became a manufacturing centre for yarn and cloth in the twelfth century. At that time, Worsted was made from the long-staple pasture wool from certain sheep breeds, such as Teeswaters, Old Leicester Longwool and Romney Marsh. Worsted wool fabric is typically used in the making of tailored garments such as suits, as opposed to woollen wool which is used for knitted items such as sweaters.

The essential feature of a worsted yarn is straightness of fibre. Wool for this yarn is made into continuous, untwisted strands which are then blended to make the fibres lie parallel. These blended strands are then tightly twisted ('worsted') and spun. Worsted cloth, once known as 'Stuff' is lightweight with a hard, smooth texture. Only long and fine-stapled wool is used to make worsted cloth. The crimp of the natural wool fibre is removed in the spinning process; the removal makes worsted fabric cooler to wear than woollen cloth made by other processes.[2]

Before the Piece Hall was built, manufacturers from the out-townships had exhibited their pieces in a large room of the White Lion inn, where they each had closets which they locked up from market to market. At that time there was a turnover of about 3,000 pieces per week. After the Piece Hall was built, one firm alone would turn over that amount, although there were still very few resident merchants in Bradford until around 1824, when merchants came to Bradford in great numbers, from Manchester, Leeds and from Germany.

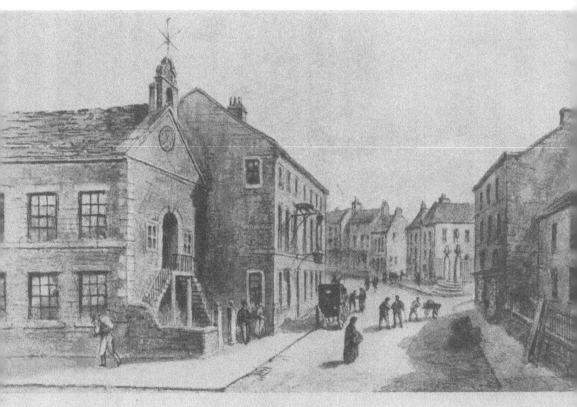

THE OLD PIECE HALL

The above illustration shows the old Piece Hall, which was situated in Kirkgate. The Talbot Hotel adjoined, and the building opposite is the original premises of the Bradford Banking Company. This was the first regular market place for the product of Bradford weavers and spinners. The building was closed in 1853.

John Hustler also helped found the Yorkshire Worsted Committee and became its first chairman; a system of inspection and supervision to prevent malpractices, fraud and embezzlement which had caused large losses for the merchants. As one of Bradford's commercial leaders, he became a principal canal investor and was instrumental in buying land for the Leeds and Liverpool and Bradford Canals. Growing business demanded more efficient transport, and the next stage of Bradford's development was the building of a canal, which became the real catalyst for the town's phenomenal expansion.[3] The canal was opened in 1774, and then connected to Liverpool in 1777, bringing an enormous boost to trade as shipping goods having become a highly efficient method of transportation. It also enabled the transport of locally mined coal, stone and iron to other parts of England and enabled the export of worsted cloth to the rest of the world.

In 1798 industry progressed even more rapidly when steam power was introduced into worsted spinning. Steam-powered machinery overtook the traditional cottage industry, revolutionising textile manufacture. Production now took place within a factory system. Instead of the time-consuming method of collecting goods from outlying cottages, factories were being built from locally-quarried stone and powered by huge deposits of cheap coal from local mines, to house huge machine looms operated by only handfuls of workers. By the end of the eighteenth century Bradford, now with a population of some 13,000 inhabitants and well into the process of growth and development, had grown from an idyllic but isolated moorland market town located on a Pennine stream, into an industrial city of international repute.

In 1836 the *Bradford Observer* noted 'The manufacturers are removing to Bradford as fast as they can get accommodated with looms.' However, mechanisation, the speeding-up of production in the process of spinning and weaving, was the cause of great upheaval. Manufacturing methods that had been unchanged since the fourteenth century were now being superceded. Although Bradford was a thriving city in the mid-nineteenth century and the textile industry was booming, one cannot ignore the extreme negative aspects of the Industrial Revolution.

It had become a world of strangers, for half of Bradford's population were first-generation immigrants; a few from Germany, some from Scotland, a great many from Ireland fleeing from the hunger and poverty of their homeland, and the great majority from other parts of Yorkshire and neighbouring counties who had earned meager livings as farmhands and smallholders in outlying areas. They would have found their new working conditions, the strict discipline of the factories, long hours and unsafe working practices, very different to farm work or the cottage-industry in which they had worked. Almost all of them came from rural rather than city backgrounds. As inhabitants of a new world, they were principally concerned with problems of economic security, personal adjustment, and the development of the social controls regarding the level of street violence in Bradford which characterized the years between 1830 and 1850.

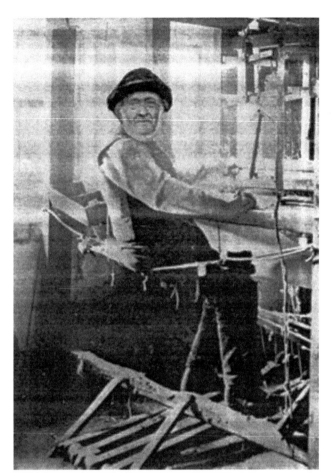

In 1910 Timmy Feather of Stanbury, who was known locally as the 'last of the Worth Valley hand loom weavers', died. Timmy led a simple life living on a diet of only porridge oats. Timmy had become something of a celebrity and would get many visitors arriving at the door of his little cottage to see for themselves how he worked at his hand loom, practicing his dying skill of hand-loom weaving. He is estimated to have woven 234,780 yards of cloth, pressing the treadles of his loom 540 million times in his lifetime. His loom and accessories are now on display at Cliffe Castle Museum, Keighley.[4]

Timmy Feather

The black bed coal was also developed into a by-product of Bradford's expanding iron industry. High-grade wrought iron was first manufactured in 1803; later, engineering was adapted to new textile demands such as the production of boiler plants, steam engines, dyeing equipment, shafting rotation rods for the transmission of power, and other millwright's work, which reached its peak during the boom trading years of 1872 and 1873.

By 1841 there were thirty-eight Worsted mills in Bradford town and seventy in the borough. By then, many of these factories were producing mixed fibre cloths. Cotton was one of the first foreign fibres to be interwoven with the long staple worsted yarn and two-thirds of the country's wool production was being processed in Bradford. By 1847 there were, by some estimates, eighty worsted mills; sixteen dye works, 250 stuff and wool warehouses, forty collieries and twenty-two quarries.[5]

Hand weaving, once considered a man's job in the old cottage industry system, had changed into power loom weaving and mechanization in general was viewed with

suspicion by workers who feared for their jobs. The fear manifested itself in Luddism (named after an early leader, Ned Ludd). The Luddites were nineteenth-century English textile artisans who protested against newly-developed labour-replacing machinery and fought against technical innovation. Mills were attacked, machinery was destroyed and manufacturers were threatened. However, once the advantages of mechanism were seen, Bradford factories began to employ women and girls to weave, due to the low price of female labour.

Regulations concerning such things as planning, building, pollution control and waste-management either did not exist or were ignored. These are also the negative aspects of industrialisation.[6]

In 1846 Bradford acquired its own railway, allowing easy access to the port of Liverpool and vital for the export of goods. More technical innovations brought the city into foremost position in the wool industry, now famous for the high-quality mixed-fibre cloth produced from cotton interwoven with long-staple wool. In 1850 Bradford had become the wool capital of the world with a population of 100,000, leading to the development of a solid engineering and manufacturing base and a key financial centre buoyed by the low price of wool, which continued to flourish.

The industry had now developed into two types of trade – a thriving home trade and the shipping of export goods. The home trade house and the foreign house were both known as the 'Stuff' houses. *Bradford Observer* reported that in Bradford 'the production of goods (had) been nearly doubled'. However, manufacturers would soon pay the penalty of overproducing. Due to a sudden increase in the cost of material, in 1857 restricted production became the rule of business, and much machinery was stopped. At no time, even in the worst periods of 1847, had the difference been wider between the cost of wool and cotton, added to the rising cost of labour, and the prices realised for the manufactured article. Excessive speculation and abuse of credit had been widespread during this low-price period which would probably have been one of the reasons for the (largely unforeseen) commercial crisis of 1857 when factory production fell to about three days a week and machines stood still for the rest.[7]

Possessing great insight, the Bradford Chamber of Commerce was highly significant in organizing the supply of long-staple combing wools at a time of shortage of suitable wools. The new Conditioning House, established by Bradford Corporation, led to an increase in the export of tops, yarns and noils (short fibres of wool) and an overall improvement in business. On top of that, Bradford had become famous for the production of mixed-fibre cloths and overtaken Leeds as the mercantile centre for stuff goods. Cotton was one of the first fabrics to be interwoven with yarn.

The Lister nip comb, patented in 1850 and fully perfected by 1853, revolutionised the combing of luster wools then dominating the worsted industry. This was used when the best results were wanted from long fibred wools and hairs such as mohair, alpaca, long English and crossbred wools, with the result that by 1854, hand combing in Bradford would become extinct.

Although Bradford had grown into one of Britain's most successful commercial cities, living conditions for workers were appalling. The rapid growth of Bradford had meant working class housing was built in a haphazard fashion. By 1851 the population

of Bradford had grown to 104,000. Over 200 factory chimneys continually churned out black, sulphurous smoke, blackening the buildings and covering the area with a blanket of soot; Bradford had now gained the doubtful reputation of being the most polluted town in England.

There were no building regulations until 1854, no sewers or drains, and overcrowding was common. Sewage was dumped into the Bradford Beck, a shallow but fast-flowing stream, once fished for trout, now a black, stinking cesspool. Fresh water had to be brought in by water carrier, from wells dug far out of town. Rubbish was piled into the streets. Animals ran about freely and rats were everywhere, causing regular outbreaks of typhoid. From 1848 to 1849, 420 people died during a cholera epidemic, which caused even more unrest among workers.

Worst of all were the damp and poorly ventilated cellar dwellings, housing whole families. These were poor families, many of them Irish, who had fled the poverty of their homeland into the poverty and squalidness of industrialisation; who used wooden boxes as tables and slept on straw or rags. Only 30 per cent of children born to textile workers lived to reach the age of fifteen and life expectancy in Bradford

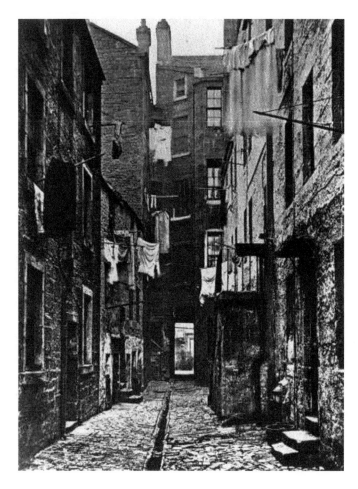

A back street slum with open mid-street sewerage drain.

had one of the lowest rates in the country. Although in 1803 an Act of Parliament had formed a group of men called the Improvement Commissioners, with powers to clean the streets and light them with oil lamps; to provide a fire engine, a dustcart and street gas lighting, such measurements had become neglectfully outdated. Conditions in these 'dark, satanic mills' in Bradford were dreadful. A twelve-hour working day was common, even for young children, some as young as five. Overseers carried leather straps to hit children who were lazy or careless.

The industrial revolution has been held responsible for the development of a distinctive class system in Great Britain. Thousands of workers (including children) generated enormous fortunes for a comparatively small minority of employers who were unwilling to pay higher wages, thus preventing improved living and working conditions, which eventually became the cause of riots, strikes, unrest and rapidly strengthening trade unions.

In 1830 Richard Oastler published a famous condeming letter in the *Leeds Mercury,*

A state of slavery more horrid than the hellish system of colonial slavery. The very streets which receive the droppings of an Anti-Slavery Society are every morning wet

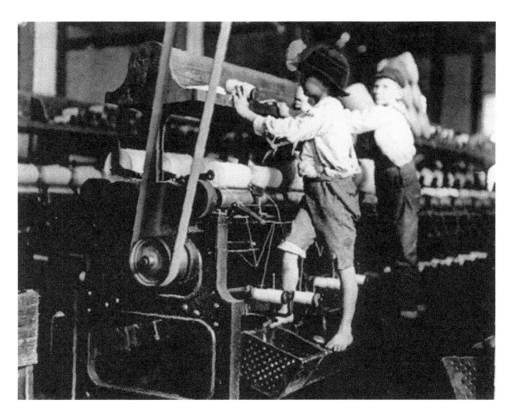

Child workers replacing bobbins: An unhappy childhood in Victorian times for children of the poor, who had to work to satisfy the needs of their families, usually eight or twelve hours a day, six days a week. Image courtesy of Wikispaces Classroom

by the tears of innocent victims at the accursed shrine of avarice, who are compelled not by the cart whip of the negro slave driver, but by the dread of the equally appalling thong or strap of the over-looker to hasten, half-dressed but not half-fed, to those magazines of British infantile slavery, the worsted mills in the town and neighbourhood of Bradford. Thousands of little children, both male and female, but principally female, from seven to fourteen years of age, are daily compelled to labour from six in the morning to seven in the evening ...with only thirty minutes allowed for eating and recreation.[8]

DEATH OF RICHARD OASTLER, ESQ.

This gentleman, whose name was once a "household word" in every working man's abode throughout Yorkshire and Lancashire, and whose memory will long be affectionately cherished there, died on Thursday at Harrogate, aged seventy-two.

Mr. Richard Oastler was a native of Leeds, but left it early in life, and about the year 1820 (we believe) succeeded his father as steward of the Yorkshire estates of Thomas Thornhill, Esq., a Norfolk gentleman of large property. It was while living in this capacity at Fixby Hall, near Huddersfield, that Mr. Oastler became a public man under somewhat remarkable circumstances. He was in the autumn of 1830 on a visit to the late John Wood, Esq., an extensive manufacturer at Bradford, when in the course of conversation that gentleman, who had discovered somewhat of the benevolent, energetic, and impassioned nature of his guest, expressed surprise that he had never turned his attention to the Factory System, adding that little children were by it subjected to excessive work and exposed to much cruelty in other ways. Mr. Oastler inquired particulars, and next morning found that Mr. Wood's mind as well as his own had been so much impressed with the subject that neither of them could sleep. The consequence was an engagement on his part to obtain, if possible, remedies for the evils which had so deeply excited the feelings of both. From that day this became the great object of Mr. Oastler's life, and in pursuit of it he spent seventeen years of almost incessant labour.

Richard Oastler was the the century's foremost advocate of better working conditions for children. He brought in the Ten Hours Act which limited the working hours for children to ten hours a day.

In 1846, George Werth, a young German on holiday in England, later a famous author and friend of the socialist Friedrich Engels, also described Bradford in a far from positive light in an article he wrote for a German newspaper,

Every other factory town in England is a paradise in comparison to this hole. In Manchester the air lies like lead upon you; in Birmingham it is just as if you were sitting with your nose in a stove pipe; in Leeds you have to cough with the dust and the stink as if you had swallowed a pound of Cayenne pepper in one go – but you can put up with all that. In Bradford, however, you think you have been lodged with the

devil incarnate. If anyone wants to feel how a poor sinner is tormented in Purgatory, let him travel to Bradford.

Blake's vision of dark, satanic mills is easily imagined. In the industry's heyday during that era, it was estimated there was a quarter of million workers in the textile industry of West Yorkshire with 70,000 of those jobs centred in Bradford. After some heated opposition by manufacturers whose sole interest was improving their profits rather than people's working conditions, the introduction of the Factory Act of 1847 reduced working hours and mill owners were banned from employing very young children.[9]

Government legislation gradually improved the terrible conditions encountered by children in the factories. The various Acts regulated working hours, workplace safety and also ensured the provision of education.

Working Hours

In 1833 a Royal Commission into Child Labour recommended that children between the ages of eleven and eighteen should work no more than twelve hours a day. Children between the ages of nine and eleven should work eight hours a day, whilst children under nine ought not to work at all. This was followed in the same year by a Factory Act which regulated working hours. Nine to thirteen-year-olds were not to work more than an eight hour day and those under eighteen were not to work at night. From 1837, birth certificates were used to prove that children were legally old enough to work. In 1844, it was ruled that older children could work a maximum of twelve hours and must be given an hour and a half for meals. The campaigning of the Ten Hours Movement resulted in the 1847 Factory Act which made the working day ten hours or fifty-eight hours a week. This was increased to ten and a half-hours in the 1850 Act but the ten-hour-day was reintroduced in 1874.

Workplace Safety

The 1844 Factory Act made it compulsory for machinery to be fenced in. It also required accidental deaths at work to be reported and investigated by a surgeon. This was followed by the Workmen's Compensation Act of 1897, after which employers were legally required to compensate for injuries and deaths at work.

Education

After the 1833 Factory Act, mill owners had to prove that they provided workers under thirteen years old with two hours of schooling a day for six days of the week. From 1874, children between the ages of ten and fourteen were allowed to work part-time in order to make time for their education. In 1880, education was made compulsory for

five to ten year olds. Compulsory education was extended to children up to fourteen in 1918.

The education system was structured in 1870 by Forster's Education Act which established Education Boards that could create new schools and pay the fees for the poorest children. In 1891, schools received grants so that they could stop charging for basic primary education.

In the same year a Corporation was formed to run Bradford, a new municipal borough to replace the old parochial and manorial administration forcing the 'privileged' class to surrender their feudal rights and financial interests.

Few regretted the extinction of this remnant of manorial control, the fierce party battle about replacing a medieval order with a new corporation was over. The idea that public good should prevail over private advantage was becoming more familiar and generally accepted. Nobody liked paying rates, but the need for public expenditure to civilize the excesses of industrialisation and control the self-centred pursuit of profit had to be conceded. Thus, despite a fierce rear-guard action by the 'economy-minded', Bradford's polluted Beck was culverted (bridged over) and a main sewer system started. The basic problems of urban engineering were being tackled.

The police force was also becoming a respectable and respected local institution. At a more personal level, functioning neighbourhoods were being created all over the town; and churches, chapels, Friendly and Improvement Societies, Temperance organisations, Trade Unions, political associations, social and sporting clubs were breaking down the anonymity of the new urban experiment. No longer did Bradford seem like a frontier town of the American Middle West and a dangerous place for respectable women; it had begun to take shape as an organised community.[10]

Although Bradford was largely a working-class town, although the wealthy manufacturers tended to live outside the range of their own factory smoke, it had also become the home of a prosperous and energetic middle class. These were managers and executives of commerce and industry, members of the expanding professions, doctors, solicitors, accountants, engineers, journalists and school teachers whose numbers doubled between 1860 and 1880. Wealthier people escaped to the suburbs, the most popular of these being Manningham. For the new rich who had made their money in industrial Bradford, the attraction of Manningham's elevated green fields was primarily as a quiet retreat from the dirt, smoke and squalor of the town. However, Bradford was expanding and was slowly reaching the boundary with Manningham. Soon, new villas were being built by wealthy merchants along with professionals such as solicitors and bankers, albeit to a dense pattern and within tightly circumscribed zones of rows of small terraced houses and more back-to-back housing workers.

> Everybody was busy spinning. A few were rich, and a great many were very poor, working from morning until night for miserable wages; but they were all one lot of folk, and Jack not only thought himself as good as his master but very often told him so.
>
> J. B. Priestley, *English Journey*.

In 1854 Bradford Corporation purchased a private water company which until then had supplied piped water to anyone who could pay. Building regulations were instrumental in improving the quality of new working-class houses although many of these appalling back-to-backs still remained for years to come. As a result of sustained prosperity in the wool trade, much-needed improvements came thick and fast. In the early 1860s many streets in the town centre were widened and improved and new links were created. By 1868, the Bradford Corporation had created a network of drains. In 1889 Bradford became the first town in Britain to have a municipal electricity supply. The corporation purchased all the manorial rights pertaining to markets and opened three new markets, to avoid cattle being sold in the street. A Court of Quarter Sessions was established in 1877 and in the same year they began the work of slum clearance. A Free Library opened in 1872, this later moved to Darley Street where it remained until the 1960s.

The Hospital Fund was started in 1873 as the amalgamation of three local Bradford hospital charities, the Bradford Eye and Ear, the Bradford Fever and the Bradford

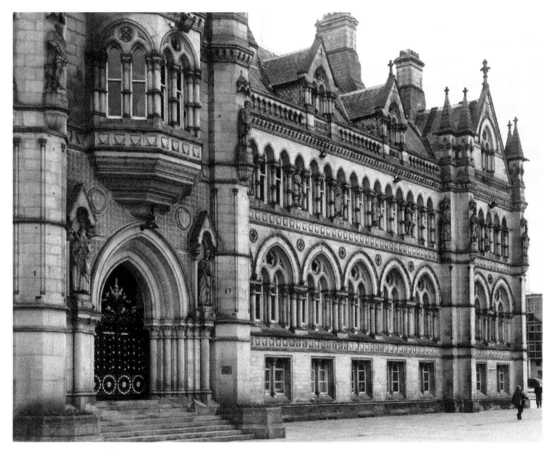

The Town Hall in Bradford, Centenary Square. Built in the thirteenth century, Gothic style to the designs of Lockwood & Mawson. The north front dates from 1870–73.
© Stephen Richards. Licensed for reuse under the Creative Commons Licence.

Infirmary. The aim was to provide financial assistance to its subscribers in the payment of certain medical fees. To create working capital with which to float the company, the recently-sculptured statues by the London firm of Farmer and Brindley decorating the front of the newly-constructed Town Hall, were placed on display in a local warehouse and the monies received from this exhibition helped to establish this very worthwhile organization. After the Second World War, the Bradford Hospital Fund gradually extended its range of medical benefit allowances and membership quickly expanded outside the Bradford boundaries. As a result it was renamed Sovereign Health Care.[11]

Trade with France, Belgium, Germany and America had increased, boosted by the American Civil War (1861–1865) and the rising demand for cotton-warp mixtures. By the end of the nineteenth century, Bradford mill owners and merchants were accumulating enormous wealth; many had become millionaires, some were already multi-millionaires. One of these 'Wool Barons' was Titus Salt (1803–1876) who introduced the manufacture of alpaca and mohair. As an outstanding entrepreneur and philanthropist, he was knighted by Queen Victoria in 1869. In 1857 Samuel Cunliffe Lister (1815–1906), another wealthy mill owner, began the mass production of silks, velvets and plushes.

The introduction of these new, cheap clothing materials was attracting even more foreign merchants. Not only did Bradford account for over 200 mills, even outlying villages and small towns had their own mills which employed most of the inhabitants. To describe the involvement of countless entrepreneurs, business and tradesmen and engineers would be beyond the scope of this book. But those who entered this country with the intention of finding work in a growing industry, to partake and reap the harvest of their ingenuity, are surely worth writing about.

CHAPTER 2

THE WOOL MERCHANTS

The first resident wool merchants in Bradford were Milligan, Forbes & Co. It appears that, before the formation of this company in 1831, there was no Bradford-based merchant devoting his full-time attention to textiles. In fact Mann Brothers Ltd, the oldest merchant house in Bradford, operating in Kirkgate as early as 1804, were better known as manufacturers of artificial limbs made of cork covered with leather.

Before the reign of the Piece Hall, which was used as a wholesale market, if a manufacturer was unable to sell his goods to visiting merchants on Thursday, which was Market Day, the costly and time-consuming alternative was to take samples personally to merchants in either Leeds or Manchester. For this reason alone the continuous presence of a merchant in Bradford was a great boon to sellers and enabled Milligan, Forbes & Co to have first choice of those goods in demand.[1]

Robert Milligan 1786–1862.

Before people from abroad began to settle in the region, many came to Bradford from other parts of Great Britain. The first mayor of Bradford, Robert Milligan, was not only the first tradesman of textiles in Bradford, he was also the son of a tenant farmer who had left his home in Dumfries, Scotland, in 1802 to join his elder brother, John, who had established a drapery business in Cross Hills near Skipton. With goods strapped to his back, Robert travelled from cottage to cottage across rough moorland tracks. After eight years of hard labour, in 1810 the handsome Scotsman set up business as a retail draper and later moved to larger premises in Kirkgate where he installed large plate-glass windows. People came from far and wide to inspect the goods on display in the shop that was 'all of glass'.

As many other merchant houses began as local drapers' shops or roving travellers, Milligan expanded to take in other kinds of textile fabrics, having familiarised himself with a wide range of textile fabrics according to public taste and changes in fashion. Robert Milligan later became a 'stuff merchant' and, due to the wide range of textile goods he dealt with, his company grew to be a significant presence in the Bradford economy.

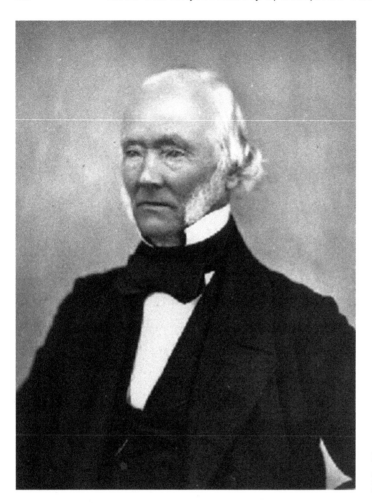

Portrait taken by Appleton & Co. in Bradford.

Robert Milligan was closely involved with Leo Schuster and through Leo Schuster he met Henry Forbes (1790–1870) with whom he went into partnership as Milligan Forbes & Co, Stuff Merchants. The business prospered exceedingly and in 1853 at a cost of £30,000 they built the first warehouse in Hall Ings in Bradford, (which is still occupied by *The Telegraph* and *Argus*).

In contrast to Little Germany, where building was done on a slope due to the lack of building space in the centre of Bradford, the Milligan Forbes & Co warehouse was built on level ground, on the water meadows site close to the Bradford Beck. The building was designed by local architects William Andrews and a Mr Delaunay. This set a precedent of warehouse design in the style of a great Italianate Palazzo with its bold horizontal emphases and large rectangular windows allowing maximum natural light in from gloomy streets.

This design became the standard, with varying amounts of high-quality architectural detail, perfected by Eli Milnes (1830–99), a Bradford architect responsible for most of the town's warehouses.

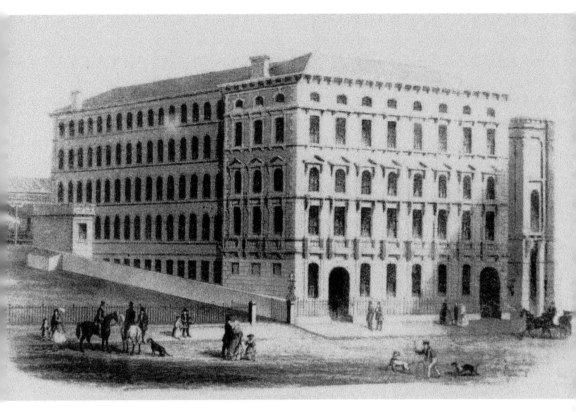

Milligan & Forbes' warehouse (Bradford Timeline – www.bradfordtimeline.co.uk).

In almost every town the palaces and temples of the time were Banks, cast in stone and marble and exuding solidity and power. Bradford was different: the warehouse came first.[2] In partnership with Henry Forbes, now Milligan Forbes & Co, and having set up a chain of drapers shops as wholesale outlets, Robert Milligan devoted his attention to textiles. His adopted daughter Susan married Henry William Ripley of Bowling, the dye works magnate. They raised a large family which is recorded in Burke's Peerage. Henry Ripley, now owner of the largest piece dye works in the world, was created a baronet in 1880.

Robert Milligan's presence as one of the very few merchants in Bradford enabled him first choice of goods in demand. Close contacts with the dyeing industry linked further connections in home trade, enabling him to influence the range of textile goods being handled by Bradford warehouses and exported to Germany.

A Liberal Non-Conformist, Milligan was a co-founder of the *Bradford Observer* in 1834, supporting such causes as the abolition of slavery in British colonies. He became the first Mayor of Bradford in 1847 and served one term as a Member of Parliament from 1852–57.

CHAPTER 3

GERMAN MIGRATION TO BRADFORD

Since 1714, Germany and Great Britain have been closely linked through the monarchy; therefore it is not surprising that throughout the centuries there has been a constant stream of German migration to England. During the fifth and sixth centuries and up to the tenth century, Angles and Saxons entered the country. Many of them were tradesmen and merchants. This continued throughout the nineteenth century until the beginning of the First World War.

The British monarchy has been closely connected with Germany since 1714, when George I from the German House of Hanover ascended the British throne. George 1 had been the first suitable Protestant successor among a long line of heirs to the throne disqualified by their Catholic religion. He was also the first of five monarchs, before the reign of Queen Victoria, to be crowned 'King of the United Kingdom of Great Britain and Ireland and of Hanover (Germany).

Victoria, who had been raised under the close supervision of her German-born mother, succeeded her uncle, William IV, who died in 1837 without producing a legal heir to the British throne. In 1840 Victoria married her first cousin, Prince Albert of Saxe-Coburg and Gotha, hence the British royal family also bore the German name Saxe-Coburg-Gotha. Queen Victoria's eldest daughter, 'Vicky', married the German Crown Prince Friedrich Wilhelm of Prussia who became Friedrich III. Their son, Frederick William Victor Albert followed his father's short reign. In 1888 he was crowned Wilhelm II King of Prussia and German Emperor.

Obviously proud of her German ancestry, Victoria remained an official member of the House of Hanover until her death, although as a female (constitutional) monarch, she had not been allowed to carry the title. When Victoria died, in 1901, her eldest son and heir to the British throne, Edward VII, inherited the title (among others) of Prince of Saxe-Coburg and Gotha and Duke of Saxony, from his German father. He was the first and only British monarch to be a member of the House of Saxe-Coburg-Gotha. Edward ascended the throne at the age of fifty-nine and reigned for nine years until his death in 1910.

When Edward died in May 1910 after a short but successful monarchy lasting only nine years, his son George Frederick Ernest Albert (1865–1936) became King George V. Due to Queen Victoria and Prince Albert's many children, there had never been such a

large assembly of European royalty present, on the occasion of his funeral. The many reigning monarchs, princes and dukes were described by Winston Churchill as 'the old world in its sunset'.

Three of Victoria's numerous grandchildren who attended King Edward's funeral, were the first cousins and monarchs, King George V of Great Britain, Kaiser Wilhelm II of Germany and Tsar Nicholas II of Russia. Wilhelm II was said to be unpopular with his English relatives. All three monarchs would be highly ineffective in preventing the declaration of war between their countries and the catastrophic First World War. It has been said that Queen Victoria would never have allowed her grandchildren to declare war against each other's countries, which resulted in the end of both German and Russian monarchies.

Because of continuing bad relations between Great Britain and Germany, George V severed all connections with his German ancestry. German names and titles were discarded, which brings us to our present monarch, Queen Elizabeth II and The House of Windsor.

The large number of German migrants entering Great Britain during the nineteenth century was partly due to the uncertain situation in their country. The rule of various German aristocrats supporting militarism prevented the formation of a middle class and the development of a liberal movement. Also, customs duties between the petty domains within the state were a burden on commerce until unification in 1871, which, however, failed to bring forth a stronger national identity. The mid to late nineteenth century saw the German economy lurch from rapid growth to depression. Increasing industrialisation placed the more rural and traditional industries under pressure, causing unemployment. Also, a rising population increased the pressure on scarce resources, leading to lower wages in a period of political change.[1]

Attracted by a more 'easy going' lifestyle in Great Britain, there seems to have been a number of waves of migrants entering the country without great formality from the 1830s onwards, covering a period of over seventy years. First the German Jews who trickled in throughout the period, then non-Jewish German merchants, engineers and generally middle class immigrants who worked as hairdressers, tailors, children's nannies and waiters. Towards the end of the period a group of German Pork Butchers entered the country. They kept largely within an established culture; upheld their traditional customs representing a larger section of German middle class migrants; therefore, we shall describe them more thoroughly in a separate chapter of this book.

Both Jewish and non-Jewish Germans developed lively middle and upper-class communities during the Victorian and Edwardian period. The cultural clubs (Vereine) catered for people on a class basis by establishing literary societies, such as the Schiller Institute (Schillerverein), where they met and socialised. It was said that they alleviated the exceptionally late hours they worked, by having long liquid lunches at the Schillerverein on Manor Row, after which they would return to their business premises, sleep off the liquor, and return to work. Trade organisations served bakers, pork butchers, tailors, waiters, nannies and other occupations. There were also welfare organizations which linked all members of the German community but in a clearly hierarchical manner, with the wealthy members of the community assisting their

poorer countrymen, therefore essentially re-emphasising class divisions.[2]

In Manchester there was the well-known figure of the composer Sir Charles Hallé and the socialist Frederick Engels. On the other hand there was the existence of a floating population of German paupers in northern towns, moving around Manchester from one charity to another. Although the German community in Bradford encountered similar problems to that of Manchester and elsewhere, the success of German businessmen in Bradford obscures the possible existence of a humbler community.

By the 1880s, the population of Bradford had risen to over 200,000, although the middle and upper class ruling élite of mill-owners, industrialists and entrepreneurs would have been small in comparison.

In *English Journey* (1934) J. B. Priestley refers to the German colony as being Jewish, but in fact the community was made up of Gentiles as well as Jews. The Germans did not all reside in Little Germany, which was considered mainly as a mercantile centre, but also lived in wealthier residential areas around Manningham. One German commentator, writing in the *Daily Mail* on 29 June 1909 claimed that, 'he had never seen so many German names in one community outside Germany, but that the German colony is remarkably small. There is no competition at all from German labour and very little of it in the professional classes'. Referring particularly to the middle class German immigrants another commentator wrote that 'their influence was out of all proportion to their numbers as reflected in the architecture of parts of central Bradford and the rich cultural heritage they bestowed on the city'.[3]

The German colony was correctly described as respectable, but it was never particularly large although their influence and the contribution they made to Bradford in the nineteenth century went, as previously observed, far beyond their actual numbers. This contribution extended into the political life of the town and those who formed Bradford's ruling élite managed to make some much-needed improvements to the town in the second half of the nineteenth century, despite being faced by a catalogue of daunting challenges. Whether their achievements were a result of enlightened self-interest, altruism, a sense of public duty or a mixture of all these, is in some way irrelevant. What mattered to these hard-headed businessmen was getting things done and getting their own way.[4]

By the end of the nineteenth century the German Protestant Church (*Deutsche Evangelische Kirche*) had rather more than 100 members. The community was substantial enough that in 1875 the German-born English Vicar, Rev. J. Kroenig, held German services in Bradford. By 1876 the congregation was able to employ their first pastor from Germany, Pastor E. Just. In 1882 the trustees bought the former Wesleyan School in the Great Horton district of Bradford for their own church. The *Deutsche Evangelische Kirche* (now the home of the Delius Centre) also benefited from contributions from the Kaiser and the King of Bavaria. It housed all the essentials of a German Protestant Church; an organ, an organ loft, pews, an alter, a pulpit, and a stone font. It even contained a vicarage which was occupied by a resident pastor until the 1970s. The church is stone-built, neo-Gothic building and epitomises Bradford's architectural heritage. Members of the widespread Delius family, the brothers Johann Daniel Delius and Rudolf Delius, wool merchants, donated three stained-glass

windows to the memory of their father, Carl August Delius, and Stephanie Delius, the wide of J. D. Delius. Now being shared with other creative and cultural pursuits, the Delius Arts and Cultural Centre has been established in the building.5

The German/Jewish community was larger, although the Bradford Jews were noted for their assimilation and lack of religious life. Historian Bill Williams commented that 'religious life was almost totally corroded and circumcision was rare', a view backed up by *The Jewish Chronicle* of 11 August 1865, which relayed that the Jews of Bradford, 'do not want to pass for Jews although every child in Bradford knows them to be Jews'.

The Chief Rabbi visited Bradford in 1870 and attempted to form a Jewish Association with very little success. *The Jewish Chronicle* reported in 1871 that services in the synagogue were held in Bradford on the High Holidays and only between thirty and forty people attended. At this time the Jewish community numbered between 200 and 300 people; a sizeable community, yet one without services or a synagogue.

'The Synagogue of British and Foreign Jews' (later renamed the 'Bradford Synagogue') was founded in 1873 and Dr Joseph Strauss of Germany was appointed to the post of director. Dr Strauss served the Jewish community for forty-nine years. It was claimed that he struggled to get people involved and interested; neither was he happy with his salary, which was said to have been less than that of a warehouse clerk. He also suffered from the dictatorial attitude of certain congregation members who were not willing to have their conscience interfered with, claiming the Rabbi's business was to interpret the ways of God to man in general, and nothing more. It can, therefore, be concluded that the Jewish community of that time was proud and free, but not pious. Some Jews attended services at Bradford's Unitarian church, presumably because they found that the Unitarians, who do not adhere to the doctrine of the Trinity or believe in the divinity of Jesus, were not too distant from the Jewish religious tradition.6

By 1911, the number of Germans living in Great Britain had peaked at 53,324, concentrating at about 30,000 in London and the southern counties. The census statistics shows a Bradford population of 553, compared to Manchester with 1,318, Liverpool with 1,326 and Leeds with a population of 470. But perhaps the greatest contribution to the culture of their adopted land lay in the Germans' offspring. Some of them would become famous artists, scientists, writers and composers. In the following chapter, we shall take a look at some of these outstanding men and women.

CHAPTER 4

THE GERMAN WOOL MERCHANTS

It was some time before the trade in general learned the lesson of their example ... the English wool trade in its expansion to every corner of the world owed a great deal to the German merchants who introduced efficient distribution and businesslike terms of payment in place of chance sales and haphazard settlement.

Memoirs of Sir Jacob Behrens.

In the early nineteenth century, home trade merchants influenced the range of textile goods handled by Bradford warehouses. Mercantile activity in Bradford had been on a fairly restricted scale until 1843 when warehouse building became a significant activity. The tempo of building rapidly increased and in 1846, when Bradford acquired its own railway, many Leeds merchants promptly moved to Bradford, which caused a temporary state of alarm as to the commercial prospects of Leeds.

By this time Bradford had perfected the new worsted industry, complemented by cotton warp giving wool materials a smoother appearance. When Bradford traders began exporting to Germany, they opened a huge market for textile goods. Consequently, German wool merchants were attracted by the potential of the rapidly developing wool trade and impressed by the vigour of growth in industrial Britain compared to stagnation in their own country. They began entering the country during the second half of the nineteenth century and soon established themselves as successful businessmen, having already been successful in their own country. Many settled around the Manningham area and carried out their trade from the Gothic-Italianate warehouses they built in the part of Bradford known as 'Little Germany'.

It is important to understand that the Germans connected with Bradford's wool industry were not textile manufacturers like Titus Salt or Samuel Lister, they were traders working hand-in-glove with the dyer and finisher. *The Yorkshire Observer*, in an article written in the mid-twentieth century, described them as follows,

Their great forte was not a technical one; they knew very little about the manufacturing side of the industry, but they allied their powers as salesmen to the prowess of their Yorkshire colleagues as craftsmen, and between the two of them Bradford captured the markets of the world.[1]

German merchants were quite different from Bradford's home-grown elite, as they brought their own culture in the form of art, music and literature. They influenced, among other things, the opening of St George's Hall, England's first civic concert hall, and they contributed much to Bradford's cultural life. They supported such bodies as the Bradford Festival Choral Society; close links were made with the Hallé Orchestra and an annual season of subscription concerts was established.

In 1851 Jacob Behrens, Charles Semon and Jacob Unna founded the Bradford Chamber of Commerce, which was greatly significant in the world-wide promotion of merchandise, one of the reasons being an improvement in trading ethics. Through the Chamber of Commerce a commercial treaty with Rumania (now Romania) was established, which brought great benefit to the textile industry of Bradford and also to Rumania. This was part of an efficient marketing system introduced by the German/Jewish merchants that was vital to the success of Bradford's industry.

The sons of the German merchants were for a time educated in a school at the Manor House Rosebery Road and The High School, Hanover Square, which was formed to give a good education to the sons of Bradford gentlemen. This school was amalgamated with Bradford Grammar School (itself patronised by Bradford's German population) when it was reorganised in 1871.

By 1861 40 per cent of worsteds produced in Bradford were being distributed by companies bearing German names, Germany being the main foreign market for Bradford-made textiles. Those who had already settled in the city attracted more merchants from abroad, using their connections to help set up and expand their businesses in Bradford. Therefore it is not surprising that thirty-eight of the founding members of the Bradford Chamber of Commerce were foreign and a quarter of its 200 plus members were from overseas. Even as late as 1904, twenty of the thirty-six merchants at the Bradford Chamber of Commerce were German or of German origin. These wealthy merchants built their homes or moved into speculatively-built houses in Little Horton and Manningham, Bradford's middle class suburbs. St Paul's Road, Wilmer Drive, Spring Bank and Oak Lane were all predominantly German streets and Manningham was very much a centre for this immigrant community.

The merchant's quarter of Little Germany contributed to the Bradford textile trades' increase from an estimated £500,000 in 1829 to about £32 million in 1869. In his *History of the Worsted Trade in England from the Earliest Times*, published in 1857, John James comments as follows on the role and influence of the Germans,

> These merchants [...] are a large and respectable colony in Bradford; they have become part and parcel of our society; are interested in the success of our trade and heartily seek to maintain our prosperity. To them, in seasons of depression, much has been owing; with judicious enterprise they have, on such occasions, bought largely for the future and thus rendered efficient aid in times of difficulty and pressure.

They were indeed entrepreneurs and some of them became men of great wealth due to the fact that the Franco-Prussian war of 1870/71 had interfered with the woollen trade between Germany and France, resulting in more German merchants transferring their

headquarters to Bradford. After the Bradford Council had set about improving the quality of life and the textile trade covered much of Europe, with especially strong ties to Germany, the Germans became a strong presence in Bradford. Trade development influenced pride, and they carried out their business in the palatial buildings placed as close as possible to the supply of textiles in which they traded. These buildings are now in the process of rediscovery; their legacy left behind for following generations to marvel about in Bradford's 'Little Germany'.

Leopold Schuster (1791–1871)

Leo Schuster was the son of a cotton merchant. He moved from his home in Germany to England in 1808, and in 1820 formed the trading company Leo Schuster, Brothers & Co., cotton merchants based in Manchester, Bradford and Liverpool. He was the first German merchant to open premises in Bradford, on the present site of the Bradford Hilton Hotel on Hall Ings, by the Interchange. Like many German Jews in north-west England at the time, he converted his faith to Unitarianism.

In 1855 he moved to London, and formed the merchant bank Schuster Sons & Co. Through this he became involved in financing various railway ventures. He became chairman of the London and Brighton Railway and then the London Brighton and South Coast Railway. On his death, his estate was valued at over £500,000, making him one of the most successful merchants of his time.

Jacob Behrens (1806–1889)

Sir Jacob Behrens was born in Bad Pyrmont near Hannover. After serving an apprenticeship at his father's company, Jacob became a buyer within the firm. At the age of twenty-eight he travelled to England to negotiate with the local suppliers. After many years of persuading suppliers to make up goods to his exact specifications Jacob recognised the advantages of having a permanent agency in England. He left his father's end of the business to his younger brother Edward and rented a warehouse and factory in the centre of Leeds, where he employed three warehouse staff operating just one rolling machine and two second-hand wooden presses.

In 1838 Jacob Behrens relocated to Bradford and lodged at the Sun Inn at the bottom of Ivegate, but left after being told 'he could not stay as he took nothing to drink'. He continued to represent his father's firm, manufacturing and packing woollen textiles. Then he established his own company, 'Jacob Behrens', to become a merchant manufacturer on his own account. When Jacobs' brother Louis came to Bradford, the company relocated to Thornton Road and became the first textile export merchant in the city. This gave rise to much greater trading and the option to expand. Two years later another branch of the company was opened in Tib Lane, Manchester, to export cotton cloth. Throughout the next few years the company underwent huge expansion. It became one of the largest textile manufacturers in Britain and exported goods

With kind
permission of
the Bradford
Synagogue.

throughout Europe, the Far East and America with branches in London, Glasgow,
Calcutta and Shanghai.

In 1869 Jacob Behrens built a new high school at his own expense, having found
the local grammar school in a wretched state and the headmaster unwilling to make
changes. His views on education became known nationally, and were sought by
William Forster, previously a wool manufacturer and later a renowned politician. He
was the minister responsible for the Education Act of 1870 which became commonly
known as Forster's Education Act.

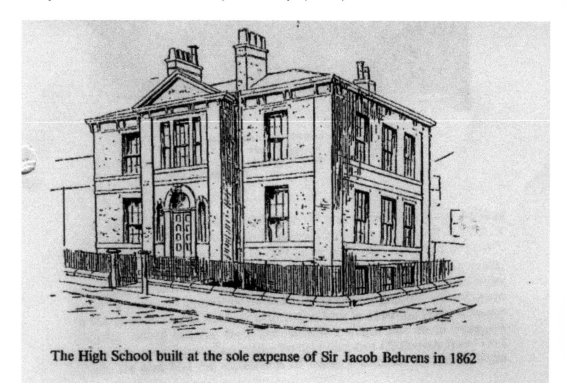

The High School built at the sole expense of Sir Jacob Behrens in 1862

Thereafter, Jacob Behrens was also active in promoting education in Bradford. He played a significant role in re-organising Bradford Grammar School and, in 1882, in setting up the Technical College, in Great Horton Road. He also helped to establish Bradford's Eye and Ear Hospital and the city's Chamber of Commerce. This enabled him to promote successfully the status of Bradford as the world's largest international wool market, by pressurising the government to improve communications between Bradford and the rest of the world, which also included modernising the postal service for sending textile samples abroad. He played a large part in drafting the 1860 Commercial Treaty with France which triggered a further boom in Bradford's export trade. He was an expert on international trade tariffs and knighted in 1882 by Queen Victoria in a ceremony at Windsor Castle for improving and strengthening trade relations between Britain and France, after a period of unrest between the two countries during the Napoleonic Era. The commercial treaty with France in 1860 also resulted in the speedy erection of Little Germany, most of which was built between 1860 and 1867.

In later years Behrens preferred to be active in charity work rather than local politics. Behrens was known as, 'a gentleman of culture and a philanthropist', his interests reaching far beyond his business.

Sir Jacob Behrens left a legacy behind him which continues to this day; the business Sir Jacob Behrens & Sons Limited is still going in Manchester and his name can still be seen, cast in iron, above the entry to his warehouse in Little Germany.

Jacob Unna 1800–1881

Another influential German merchant was Jacob Unna, who was Behrens' right-hand man. Born in Hamburg, Germany in 1800, Jacob Arnold Unna came to England in 1820 as a young man with the spice of adventure and a zest for ambition and achievement. On arriving in Manchester, he honed his prospects and then moved on to Leeds. In 1884 he finally transferred his worsted trade business to Bradford, seeing Bradford as the next major boomtown. This move proved significant to the commercial history of Bradford due to Unna's later association with the city's Chamber of Commerce and although he might not have had as big an impact on Bradford's Jewish life as others, such as Jacob Behrens, Jacob Moser and Charles Semon, he still played a significant role both in Jewish life and the wool trade within Bradford.

Jacob Unna was a promoter of the Bradford District Bank and financially supported Bradford's Eye and Ear Hospital; a building completely demolished in the 1970s. As a Grandmaster Freemason, he founded Harmony Lodge. He also gave generous amounts to charity in the spirit of the times, as many wealthy Victorian businessmen felt it their duty to help the poor and needy.

In 1880, as the 'Grand Old Man' of the newly formed Bradford Jewish Community, he laid the foundation memorial stone for the future Reform Synagogue. Jacob Unna and his wife Serine, who lived in the grand town house of No. 2 Eldon Place, off Manningham Lane, had one son and two surviving daughters.

When Jacob Unna celebrated his eightieth birthday at Eldon Place, his grandson wrote a letter to his father (Jacob's son) telling him about the party. This letter gives us a unique window into life in this house and Victorian Jewish Bradford:

14 February 1880
My Dear Papa,

I am sure that we were all very sorry that you were not here on Grandpapas birthday and since you were not here I will give you an account of all that happened on that day: we had breakfast at eight o'clock and then we went down to Eldon Place; when we got there we found that the Lewis's had got there before us; we had to wait about a quarter of an hour, and then Grandpapa came down; just as he opened his bedroom door we began to sing a song called … when he got downstairs (which of course took sometime), we all wished him many happy returns of the day; then he sat down in his chair, and we showed him all the letters and telegrams that had been sent; then he went round to see his presents, among which were; a big … from Auntie Ette, a foot warmer for his bath chair, and from Alice a picture of herself as she was at the fancy dress ball; from Auntie Emily a cake with eighty candles round it, and a big one in the middle; from Auntie Fanny a beautiful rug, the inside of which is like Mama's new cloak; from Auntie Annie a lot of notepaper and envelopes; from Uncle Leopold a new office chair; from Auntie Yetta his armchair newly covered and from Fraulein Jeinsen a new domino box, outside covered with fern leaves, and inside with leather, and from Nellie and I the words of the song written on an ornamental piece

of cardboard. After he had seen all his presents we went into breakfast, while we were yet at breakfast Mr Hamburg came in and he was the first visitor who came to wish Grandpapa many happy returns of today; soon after breakfast the visitors began to come; after breakfast Uncle Joe gave him his present which was a hamper of port from 1798. Among the visitors were Mr and Mrs Lartzarous who had come from Manchester on purpose; visitors kept coming, all the morning till about half past one and at this time the gentlemen from the Lodge came; they came and wished him many happy returns of the day and then Mr Crabtree first made a speech and after the speech gave him an illuminated address and after that the silver salver; then Mr Wilsman made a speech and after him Doctor Strauss, after they had gone we went into dinner at which we were all present, after dinner the ladies and gentlemen came as before; I forgot to say that three gentlemen Mr Nathan, Mr Thaliske and Mr Voigt came before dinner to wish Grandpapa many happy returns in the name of Schiller Wirein.

Visitors came just after dinner and then at about four o'clock Mama and Nellie went home with Emily and Harry who had come down at about twelve, to dress for the party in the evening: in the evening there were all Grandpapa's old gentlemen friends, all the relations and besides those Mr Wood and Mr Cohn; when the first half of the people were in at supper Grandpapa of course among them, a choir from Doctor Jufts choir came and sang two songs and as soon as they had sung they went away without anybody knowing who they were; we three children also sang the chorus of the song that we sung in the morning, when they proposed Grandpapa's health: we went home at about half past nine, and Mama came home at about eleven; we had holiday all the day, although we expected that we should have had to go to school all the day; during the day forty-five visitors came and Grandpapa got about thirty-five letters.

Just less than a year after these happy scenes at his eightieth birthday, Unna died. One of his grandchildren was the famous actress, Dame Peggy Ashcroft (1907–1991), whose own granddaughter is the contemporary French author, composer and singer, Emily Loizeau.[1]

Charles Joseph Semon (1814–1877)

Charles Joseph Semon, also of German Jewish descent, was born in Danzig in 1814. He came to England while the worsted trade was still in its infancy and in early manhood became a naturalized Englishman. From that period until shortly before his death he was one of the most active commercial men in Bradford and soon built up one of the most important textile export-houses in the town. The trade carried on by his business was enormous. He dealt in yarn, stuffs, worsted, and woollens and it was claimed that each of these were sufficient to form a trade in itself. The firm supplied these goods to all the principal markets all over the country, and also exported on a huge scale to Australia, the United States, and to the continent of Europe. Charles Semon's expertise

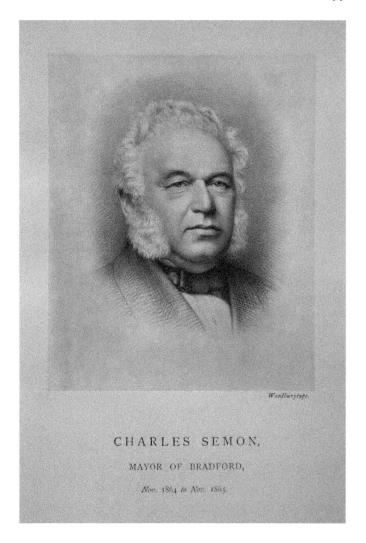

CHARLES SEMON,

MAYOR OF BRADFORD,

Nov. 1864 to Nov. 1865.

With kind permission of
the Bradford Synagogue.

was not only running a successful textile export business but also as a leading light in Bradford's municipal affairs, charities and education. He became the first foreign-born and Jewish Mayor of Bradford in 1864; was an active member of the Chamber of Commerce and served for many years on its council, becoming its Vice-President in 1871. It was on his initiative that the Bradford Chamber of Commerce conducted meetings with Romania, which brought great benefit to the textile trade of Bradford. He was also a Justice of the Peace for both the Borough and the County and a Deputy-Lieutenant of the West Riding of Yorkshire. Well known for his charitable and philanthropic work, including the building of a convalescent home in nearby Ilkley in 1874, he handed it over to Bradford Corporation in 1876 with an endowment for its upkeep.

Charles Joseph Semon died in Switzerland in 1877. In his will he bequeathed £35,000 for the benefit of educational institutions in Bradford.

Jacob Moser (1839–1922)

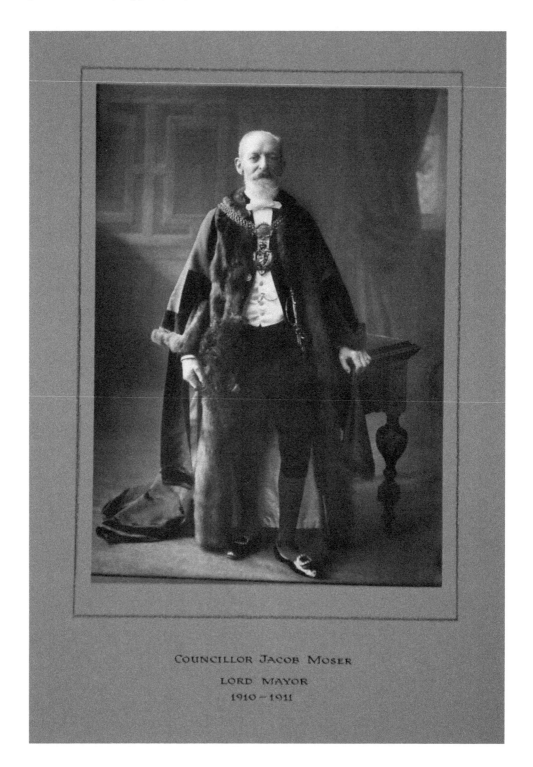

COUNCILLOR JACOB MOSER

LORD MAYOR

1910 – 1911

Jacob Moses was born in 1839 in Kappeln near Schleswig (then Denmark, now north Germany) His father was a textile merchant and his Jewish parents, being passionate about him learning Judaism and Hebrew, sent him to Hamburg where he also studied modern languages. Later, he joined his father's business to learn the textile trade. Following the example of his uncle, a local doctor, he changed his surname to Moser before going to Paris. From there, having developed close connections with British textile manufacturers and being attracted by the rapidly developing textile industry, he moved to Bradford. He worked at various companies, such as W. Herels, Jonas Simonson & Co. and Hirsch, Pinner and Co. until he had saved enough money to start up his own business. In 1872 he went into partnership with Victor Edelstein, also of German-Jewish descent, and soon became the leading partner in the firm of Edelstein, Moser and Co. By this time, he had already relinquished the rights to his father's business in Kappeln, in favour of his brother, Adolph.

The firm Edelstein, Moser and Co. expanded rapidly and became one of the leading and most successful exporters of textiles in Bradford. In 1902, an imposing warehouse was built to accommodate the Bradford company in 'Little Germany'.

Now a wealthy man, Jacob Moser concentrated mainly on his social and philanthropic interests. Along with Jacob Behrens and other influential merchants, he belonged to a group of philanthropists who had built Bradford's textile industry and were now keen to help people less fortunate than themselves in improving their skills and quality of life. This group of merchants, using their wealth and influence, established the Bradford Technical School, now Bradford College. The building cost £23,500, had classrooms for 700 students and a 1,500-seat lecture room. Like the City Hall and St George's Hall it was designed in the (then) fashionable Italian style and opened by William Edward Forster in 1871.

Jacob Moser and his wife Florence remained childless. Much of their social work was devoted to the welfare of children in the industrial slums of Bradford and large sums of money were donated to families in need of financial assistance, as described in the following short biography of Florence Moser. They also supported the new building of Bradford Royal Infirmary and purchased 12,000 books for Bradford Central Library. Bradford Scientific Association and The Discharged Prisoners Aid also benefited from their generosity.

Jacob Moser was a practising Zionist. Not only was he a founder of the Bradford Reform Synagogue and an ardent supporter of the State of Israel, he also supported and financed Jewish schools, educational institutions and social organisations. Having become a British subject, Jacob Moser was active in local politics and from 1910–1911 was Lord Mayor of Bradford.

Although his home was in the Manningham area of Bradford, he still took a great deal of interest in his home town of Kappeln in Schleswig-Holstein. He financed the town's hospital and old people's home, also the town's water-supply for which he was made an honorary citizen.

Jacob visited Israel in 1908 and 1910 where he supported the Herzliya Gymnasia also known as the Hebrew High School in Tel Aviv and Bezalel School of Art in Jerusalem, which was opened in 1906. These schools attracted pupils from across Europe, Palestine and America.

In 1921 shortly before Moser's third journey to Palestine, Florence Moser died. Jacob retired from his charities and died one year later in 1922. Jacob and Florence Moser were buried in Bradford's Jewish Cemetery. Two streets in Bradford were named after him and one in Tel Aviv. Moser Avenue and Moser Crescent lie on the Swain House Estate in North Bradford, which was constructed during the inter war years, while Moser Street or Ya'akov Mozer is situated just off the David Yellin Road in the centre of Tel Aviv, a short distance from the Marina.

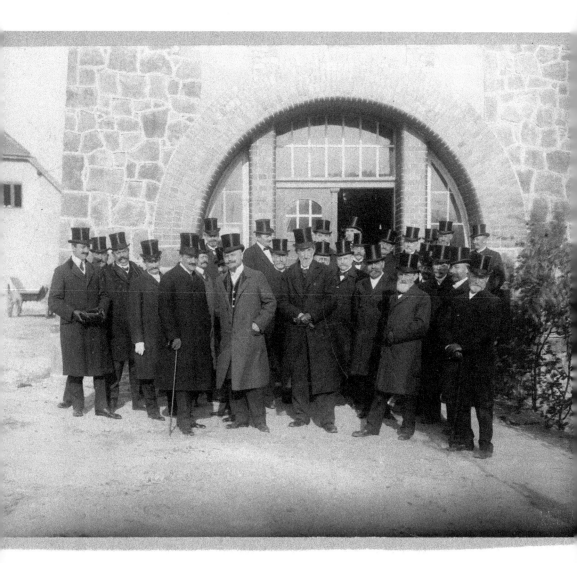

Jacob Moser (second from right, front row) outside the waterworks in Kappeln (Kappeln archives). Not forgetting his home town of Kappeln he supported a nursing home for the aged, a local hospital (which no longer exists) and donated towards the central waterworks and water tower, for which he was made an Honorary Citizen of Kappeln. With kind permission of the Kappeln Archives.

Florence Moser

Florence Moser is best remembered for her great help for working mothers with young children.

She opened a small place in Wynne Street, Westgate, known as 'The Nest'. Here working mothers, often widowed, could leave their babies and young children to be cared for and fed during the day. A small charge was made, but the nursery and dining-room were financed and run by an efficient staff under Mrs Moser and her helpers for about twenty-six years. She established the City Guild of Help, a form of organised help for the poor and distressed, a system which has been adopted in many other places on the Bradford model. Florence Moser was a member of the Board of Guardians for ten years and for three years acted as vice-chairman.

An article in the *Telegraph & Argus* of 2 July 1960 about Florence, states that 'her method was to work from the small to the great; she was a blend of the idealist and the practical woman'. Her ideas were well in advance of social progress and she endeavoured to overcome the injustice of many conventions of the late nineteenth century.

Victor Julius Edelstein

Born in Binteln-on-Weser, Germany in 1842, Victor Edelstein came to England in 1868 and for a year lived in Leeds before settling in Bradford. He met a fellow German merchant, Jacob Moser, and within three years had a business partnership which was to flourish for over thirty years. Victor Edelstein was a member of the Council of the Chamber of Commerce, Director of the Wharfedale Estate Company, and Chairman of the Joint Hospital Committee.

He married Anne Gottschalk of Dusseldorf, daughter of J. Gottschalk, Director of The Hebrew Grammar School in Jaffa, called 'Herzlia Gymnasium' and created in 1906 for the purpose of providing a European secondary education through the medium of the Hebrew language and spirit and adding to this a knowledge of Hebrew culture. It also aimed to prepare its pupils for universities and technical schools so that they would become professional people working in Palestine and the adjacent countries.

In 1894 Edelstein was elected the Bradford Consul for the German Empire and kept this position until the beginning of the First World War.

Bernard Cohen (1836–1904)

Born in Altona, adjacent to Hamburg, which until 1866 was actually part of Denmark, Bernard Cohen began to work at Dehn and Meilchior, Hamburg, and later moved to their Manchester office where he became a merchant dealer in cloth. In 1860 he moved over the Pennines and started working for Charles Semon and Co. as manager of their

Bradford branch. In 1868 he became a senior partner in the firm which dealt in yarns, stuffs, worsted and woollens on a large scale. After the death of Charles Semon in 1877 he became the sole surviving partner of the company. Bernard Cohen made it his duty to carry on the far-reaching work of his predecessor and became a member of the Council of the Chamber Of Commerce in Bradford. He also had links to the Technical College; the academic foundations for both Bradford College and the University of Bradford of today.

The Schlesinger Family

Julius Schlesinger, born in around 1817/18 in Hamburg, was noted to have disembarked from the 'William Darley' at Hull in 1837. This could have been when he arrived in this country to settle, but it is also possible he was merely at that stage visiting various family members, also born in Germany but settled in Bradford and had since become naturalized citizens – all being one way or another connected with the cloth industry.

In 1842, Hermann Schlesinger was listed as a merchant living in Manchester Road, Bradford. In the census of 1850, Andrew, Julius and Martin Schlesinger (all born in Hamburg, Germany) were listed as yarn merchants and manufacturers around the Manningham area. Andrew was a yarn merchant with Quitzow, Schlesinger & Co. and Julius and Martin were listed as attending the Bradford Wool Exchange on market days. In 1870, Andrew Schlesinger was listed as a yarn merchant at No. 27 Peckover Street and Julius was listed as a stuff and woollen merchant at No. 16 Church Bank (Little Germany).

The Delius Family: Julius and Elise Delius

Julius Delius, the father of the famous composer Frederick Delius, was born 1822 in Bielefeld, a thriving linen-manufacturing town in the Prussian province of Westphalia, Germany. After coming to England he spent a few years with a merchanting firm in Manchester before moving to Bradford. He worked first for S. E. Sichel in Bradford before going into partnership with a Mr Speyer. When Speyer left Bradford Julius and his brother Theodore went into partnership and formed the company Delius and Co.

Julius Delius is first recorded in Bradford on the 1851 census as a lodger in the house of John Walker, woollen manufacturer and stapler at No. 3 Manor Street, described as a twenty-nine year old stuff merchant, born in Prussia. In 1856 he returned to Bielefeld to marry Elise Kroenig, who was about sixteen years his junior. The Delius and Kroenig families had intermarried frequently.

Julius Delius, having built up a successful business from scratch, hoped that his sons would follow him into the business. However, it was not to be; not one of his remaining three sons was to play any significant role in the firm. His eldest son Ernest, a born wanderer, must have been a big disappointment to him, preferring sheep farming in New Zealand to the textile trade in Bradford. Max, the youngest son, became a

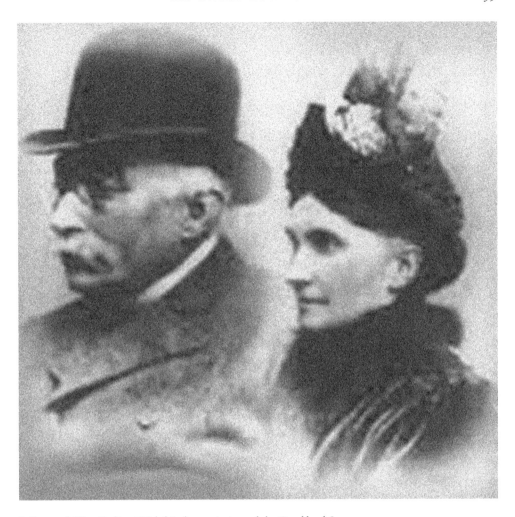

Julius and Elise Delius. With kind permission of the Bradford Synagogue.

partner in the company but the partnership was dissolved. He later set up in business on his own account. In 1901 he was declared insolvent to the extent of nearly £6,000 after incurring debts as a result of Stock Exchange and turf speculations in addition to financing a failed touring theatrical company. Max Delius died in Montreal, Canada in 1905.

As an export house the firm would have been adversely affected, as all Bradford trade was in the late nineteenth century, by the establishment of tariffs by many European and American governments to protect their own trade. By 1906 trade directories show the firm of Delius & Co., export merchants as having moved to No. 153 Sunbridge Road, Bradford. There is no record of the firm after this date.

Frederick Delius (1862–1934) was born in Bradford in 1862, christened Fritz Theodor Albert Delius and educated at the Bradford Grammar School. His parents intended him to follow a career in business but Fritz had a passion for music. Fritz,

who later anglicised his name to Frederick, was Julius and Clare Delius' second son. He began quite well in the wool trade but could not ignore the longing to develop his musical interests. Business trips to the continent exposed him to more music. Sadly, although Julius must have been aware of his second son's talent, he couldn't bring himself to support him in a career in which he saw no chance of financial security. His father set him up in a business partnership in an orange plantation in Florida, but Frederick spent most of his time enjoying American music including the songs of black plantation workers. After eighteen months he left his brother Ernest in charge and moved to Virginia to teach music before studying it formally at the Leipzig Conservatorium in Germany.

After graduating, Delius moved to Paris and began his professional composing career. He drew inspiration for his works from many international sources including literature and music from England, France, Germany, Denmark, Norway, black Americans and North American Indians. He was also inspired by various landscapes he visited, including Florida and the Scandinavian mountains.

In 1893 William Shaw, secretary to the firm Delius & Co., wrote to Frederick, 'Latterly business affairs have tended towards an utter collapse. Your brother [Max] having no financial interest in the concern, appears to have no control or say as to how the business should be conducted. It is the general opinion of employees that your father is not abreast of the times and unless he ceases to manage, not a customer worth a straw will be left in six months time.' Shortly after, Max left the business and set up on his own account with unhappy results.[3]

Under the photo is written: *Frederich Delius Minde om en Sommermorgen paa Haukelifjeld* (Frederich Delius memory of a summer morning at mount Haukeli). Original belongs to the Edvard Grieg Archives at Bergen Public Library.

By 1903 Frederick was a famous and accepted composer and had married Helene Jelka Rosen, a German painter, the couple settled in Grez-sur-Loing near Fontainebleau in France. When failing health meant he could no longer compose, his last works were completed by dictation to Eric Fenby, a young musician from Delius's native Yorkshire.4

Clare Delius

The house that Julius Delius chose for his family home in Bradford was a large middle-class villa, indicative of his growing wealth and built on a hillside above the squalor of the town centre in what was open country at the time. The family home is remembered by Frederick's sister, Clare Delius, in her writing, 'Frederick Delius: Memories of my brother'. It was in fact two houses, Nos 1 and 3 Claremont, joined together to accommodate the large family of ten girls and four boys. There were also servants living in the house: a cook, a nurse, a general house and a sewing maid.

In her book, Clare Delius describes their garden as being 'a private thoroughfare', meaning that for many years the public were denied access to it, although she remembers mill hands being allowed to pass through it on their way to work and recollects the sound their clogs made. 'For many years the residents were content to maintain their rights as against the public by closing the gates once a year, but on account of the alleged damage done to the gardens, especially my father's garden, the privilege of using the avenue was finally withdrawn.'5

It was very much a wealthy middle class street as the census returns demonstrate. In 1861 there were already five German families living in the eighteen houses, with fourteen of the heads of households involved in the Bradford trade as either manufacturers or merchants. In 1871, in twenty houses, there were eight German families and twelve merchants.

After the death of Julius Delius in 1901 the house was sold. In 1908 when Ernest William Busby moved to Bradford to set up business as a draper on Kirkgate, he moved his family into No. 1 Claremont. He told his children the house was 'built like a stone fortress'. By way of welcome, an established neighbour told Ernest that 'the people who used to live at Claremont were somebodies.'6

William Rothenstein

His father, Moritz Rothenstein, was born in Grohnde near Hamelin in Hanover in 1836 and there he served his apprenticeship as a textile merchant. In 1859 he arrived in Bradford to open a small warehouse in Hall Ings, trading under the name M. M. Rothenstein and later in 1886 from No. 66 Vicar Lane under the newly-formed company of Rothenstein and Falkenstein. He and his wife set up house at Spring Bank in Manningham where William was born in 1872.

Following the outbreak of war in 1914 the Rothensteins were affected by prejudice towards German names. With his brothers Charles (who carried on the family business

With kind
permission
of the
Bradford
Synagogue.

in Bradford) and Albert, Rothenstein decided to change the family name to Rutherston. At the moment of legal commitment, William decided that the change meant too great a sacrifice of continuity and identity, and he alone continued to carry the name of Rothenstein. Through Charles à Court Repington he approached the War Office in 1916 with a proposal that official war artists make (as the Germans were doing) an artistic record of soldiers and scenes of action. After much bureaucratic delay, the

plan was approved, though he had little hope, in view of his German name, of being appointed an official war artist. In December 1917 he was finally allowed to go to the Western Front, where indeed his name did cause some difficulty. Painting as close to the front lines as he could get, he was at one point mistakenly arrested as a spy. Many of his battle scenes painted both before and after the armistice are in the collections of the Imperial War Museum in London.

Now a world famous artist, William Rothenstein was knighted in 1931 for Services to Art. He attained the position of Principal of the Royal College of Art and a Trustee of the Tate Gallery. In 1934 he received the honorary doctorate of D. Litt from Oxford University. A number of his works were acquired for the Tate Gallery and the National Portrait Gallery in London. When the Second World War began Rothenstein again offered his services as a war artist, though poor health kept him from going abroad. Instead he made portrait drawings of airmen at RAF bases in England, many the last likenesses of those who did not return. (The Imperial War Museum, London, and the Royal Air Force Museum, Hendon, Middlesex, have many of these in their collections.) In the last year of the war his health declined again and he died at Far Oakridge 14 February 1945 and was buried at St Bartholomew's Church, Oakridge, Gloucestershire.

Max Beerbohm acknowledged that Rothenstein had been 'assuredly a giver, a giver with both hands, in the grand manner'.

The Bergson Dynasty

The Bergsons were originally called Kreutzer but this was changed on their arrival to the UK in Sunderland when Philip Bergson asked the name of a prominent and successful local Jewish family and thus adopted their name, in the interests of settlement and survival.

The Bergsons were immigrants from Riga and ran a large tailoring business on Barkerend Road. They had originally come from Birzie, Lithuania. After Meyer Kreutzer married Hoda Hyman they went to live in Riga where Hoda had eight children. In 1890, the family (without Meyer) arrived at Hull, travelled to Sunderland and then on to Bradford.

One of Hoda's sons, Joseph Bergson, was an award-winning photographer and the youngest in the Bradford area; his studio, 'Studio Jorik' was on Manningham Lane. Another son, Max Bergson, was a crack shot and world champion weight-lifter. He achieved the world record in 1925 in the 10 stone class and his cup is still being presented.

Other members of this large Bradford family were the playwright sisters Renée and Esther Bergson-Brown. They wrote *Rosie's Sweet Shop* and *Our Tale of Two Cities* which the critic John Slater wrote about in the *Jewish Chronicle* in 1955. Esther married Edgar Rothschild (1924–2012) who as a teenager had come from Hanover in Germany to England in 1939. The couple had three children; the Rabbi Walter, his sister Rabbi Sylvia and their sister Joyce, an education consultant.

According to Raymond Dunn, an economic migrant to Bradford from North London in 1975, there used to be a derelict cluster of shops near the junction of Listerhills Road and Thornton Road. One of the empty shops bore the name 'Bergson Tailors'. Another successful member of the family is the film critic, presenter and scriptwriter Phillip Bergson. Educated at Bradford Grammar School and then Balliol College, Oxford, Bergson has written for both the *Sunday Standard* and *Sunday Times* newspapers.7

Ernest Sichel (1862–1941)

Some three generations of the Sichels were active in Bradford's Textile industry, the most famous of them being Ernest Sichel. His father, Victor Sylvester Sichel, was the manager of the wool merchants Reiss Bros in Currer Street and his mother, a daughter of Henry Foster, one of the founders of S. & H. Foster Ltd, Spinners & Manufacturers.

Ernest Sichel, the Bradford artist, who is the subject of an article on this page.

Yorks. Evening Post. Nov. 21 '32

With kind permission of the Bradford Synagogue.

Ernest was a close friend of the composer Frederick Delius. They lived opposite each other in Claremont, Horton Road and were pupils of Bradford Grammar School at the same time. Ernest Sichel lived and made his mark in the art world of the late nineteenth century and much of the first half of the twentieth century, acclaimed as a fantastically great painter of portraits, landscapes and watercolours, as well as being a studious and meticulous silversmith and sculptor. As a young man he occupied a studio off the Euston Road, between Kings Cross and Regents Park, adjacent to the studio of John M. Swan, the famous draughtsman and pictorialist of animals. Sichel and Swan became very good friends. Tired with the lure of London, the two of them felt the urge to go to Paris and study the mural paintings of Purvis de Chavannes, which became a great influence on Sichels own creative output.

Upon his return to Bradford during the 1880s Sichel set himself up as a painter of portraits and spent the rest of his life in and around Bradford, effectively snubbing the bright lights of big cities. Some of these commissions were of prestigious local doctors such as Bronner and Bell, as well as Bradford's 'Merchant Prince' and founder of the Bradford Chamber of Commerce, Sir Jacob Behrens, who 'gave early proof of his great technical endowment'.9 Oils, water colour and pastels were not his only media. He designed ecclesiastical embroidery and bronze and silver work, and shortly before his death, a small-scale statuary.

Sichel, a bachelor, died in Bradford on the 20 March 1941. He is now recognised as one of the forgotten grand masters of the English art scene, having left a legacy which could have been coveted by any of his period contemporaries. Foremost among his admirers was Sir William Rothenstein, who wrote warmly of Mr Sichel in his memoirs, published in the 1930s.

Edward Albert Lassen (1876–1938)

Edward's paternal grandfather was Edward Samuel Lassen (born 1816). He originated from the Mecklenburg lake area of north Germany and became a naturalized British subject. He and his wife settled in Bradford and Edward's father, Albert William Lassen was born in Bradford in 1847. According to Kelly's Directory of West Riding of Yorkshire, 1881, Albert William Lassen at No. 3 Mount Royd, Parkfield Road, Manningham, Bradford, was in the Bradford court section as being Austro-Hungarian Vice-Consul at No. 45 Well Street, Bradford. However, Edward, Albert's son – known as 'Uncle Bertie', became the subject of many family anecdotes regarding his golfing, his man-about-town nature and his chess-playing. He was probably more widely known as a golfer than a chess player, having played in the Yorkshire-Lancashire match of 1899 and 1900 as well as for Bradford in the Woodhouse Cup for 1899 onwards, on one of the top three boards. He also won the Yorkshire golf championship in 1900, 1908, 1909, 1913 and 1914, and was runner-up in 1906 and 1922. He won the British amateur golf championship in 1908, and was runner-up in 1911. In 1928, Edward was recorded as a stuff merchant, operating from No. 72 Vicar Lane, but business might not have gone well, as he was mentioned in connection with a Bankruptcy Receiving Order in November 1928.

Martin Wolfe: (1885–1894)

Matin's family originated from Schwaan in Mecklenburg, Germany. He later moved to Milan in Italy. Very soon after coming to Bradford in 1885, Martin became a partner in the firm of Stuff Merchants Simon, Israel and Co. based in Manchester, Hamburg and Bradford, at No. 44 Vicar Lane in Little Germany. Many family members changed the spelling of the family name to 'Wolfe', after the sinking of the *Lusitania* by a German submarine during the First World War and the ensuing public outcry.

Martin's son, Humbert Wolfe 1885–1940, the British poet and civil servant, was born in Milan, Italy. His mother, Consuela, was Italian. Humbert was brought up in Bradford and was a pupil at Bradford Grammar School. He became one of the most popular British authors of the 1920s. He was a contemporary of J. B. Priestley and although his career was in the Civil Service, it began in the Board of Trade and then in the Ministry of Labour. By 1940 he had reached a high position and was recognized with the CBE and then a CB.

Wolfe said, in an interview with *Twentieth Century Authors*, that he was of 'no political creed, except that his general view is that money and its possessors should be abolished.'

Humbert Wolfe, painted in 1931 by his friend William Rothenstein. With kind permission of the Bradford Synagogue.

Dr Frederick William Eurich (1867–1945)

Dr Eurich, a bacteriologist, was one of the most significant members of the German community, he was an unassuming man who will be remembered for his painstaking work in many fields of medicine. He was born in the town of Chemnitz, Saxony. His father Carl Richard Eurich had been an agent in Chemnitz for a German textile firm in the commercial district of Little Germany and came to England with his family to join the Bradford branch in 1875.

Frederick (known as Fritz) arrived in Bradford at the age of seven. He was educated at Bradford Grammar School and studied medicine in Edinburgh. In 1896 he opened a general practice in Bradford and in September 1900, married his wife Guen in Bradford. Because of a high degree of poverty and ill health in the city, he began to hold a free Saturday morning surgery at the Bradford Royal Infirmary.

His theories on penal reform, the treatment of delinquents and his theory that mental breakdown might be related to physical illness were years ahead of their time. It had become painfully obvious that numerous negative aspects were accompanying Bradford's success in the woollen industry. One of these was the spread of pulmonary anthrax resulting from the inhalation of spores of an anthrax bacterium that

Dr. F. W. Eurich at the time of his retirement, 1937, aged 70.

Image taken from *Dr Eurich of Bradford* by Margaret Blign.

contaminates wool, a fatal illness commonly known as 'Wool Sorter's Disease'. This had grown to be a widespread hazard in Bradford's textile mills, with infected wool being the major cause. Alpaca and mohair from central Asia had been identified as the primary source of the disease. In attempt to offset the problem, the City Council opened a Pathological and Bacteriological Laboratory, appointing Dr Eurich as the chief bacteriologist. Originally located in the Technical College, the laboratory relocated to Morley Street, a short walk away from his house.

The Bradford Anthrax Investigation Board was founded and Dr Eurich developed a great level of expertise in the field of Bacteriology. The investigation involved the bacteriological examination of about 14,000 samples of wool and hair and the virulent nature of the anthrax bacillus was a constant and serious danger to Dr Eurich himself. He discovered that, 'contrary to expectation, wools might be as dangerous when clean as when dirty' due to the fact that bales of wool were often contaminated with blood or skin containing the anthrax bacillus. Workers quickly made the link between these wools and the illness described as 'bronchitis, pneumonia, and so-called blood-poisoning of a peculiar deadly nature'. Those who sorted the bales were most vulnerable to this so called 'Wool Sorters Disease', or 'la maladies de Bradford', though other cases were known, such as: a woman who washed her husband's contaminated clothes, or a boy who fell asleep on a bale of wool. Death could result within a day or so, accompanied by terrible pain.

In his capacity as Bacteriologist to the Bradford Anthrax Investigation Board, the latter spent many dangerous years growing and experimenting on the bacillus, until he finally discovered a method of killing it by disinfection and removing the danger without spoiling the fleece or harming the workers. A Wool Disinfecting Station was built and opened in Liverpool in 1918 and the Board devised more medical initiatives in the fight against anthrax, including 'improved treatment of the disease when contracted, and effectively reducing its fatality'.

Workers in wool owe a large debt of gratitude to Dr Eurich for his long-sustained work on the dreaded 'Bradford disease', although he never got the full credit he deserved for his victory over anthrax.[10] On Friedrich Eurich's death in February 1945 the *Yorkshire Observer* recorded that 'he did so much to conquer the disease of anthrax and his contributions in the cause of medicine were so outstanding.'

Richard Eurich

Richard Eurich was the second of Dr Eurich's five children. He was sent to St George's School, Harpenden, at the age of ten and then attended Bradford Grammar School from 1918 till 1921. Richard then studied at Bradford School for Arts and Crafts in 1922 and continued his training at the Slade School of Art under Professor Henry Tonks until 1926. Richard Ernst Eurich, OBE, RA (1903–1992) became a well-known English painter. He worked as a War Artist to the Admiralty in the Second World War and was also known for his seascapes and narrative paintings. These were often invested with a sense of mystery and wonder, which have tended to set him apart from mainstream development of art in the twentieth century.

CHAPTER 5

THE DEVELOPMENT OF BRADFORD'S LITTLE GERMANY

Section of Map of Bradford dated 1832 (Little Germany Conservation Area Assessment).

The land upon which Little Germany was built had a direct affinity with the church. The Vicarage, built in 1695 on the junction of Vicar Lane and Church Bank, is thought to have been one of the earliest buildings on this site.

In 1797 Edmund Peckover, a prominent Bradford wool stapler, a successful Quaker banker and financier in the construction of the Bradford Canal, bought the land. Almost immediately he began the construction of a country house for himself. Eastbrook House, situated at what is now the top of East Parade, was constructed at the beginning of the nineteenth century.

Further development didn't begin until after Peckover's death, when Charles Harris, Peckover's nephew and one of the founder partners of the Bradford Old Bank, took over the estate in the 1820s. Most of the buildings constructed at that time have since been demolished, although some good-quality small houses are still in evidence on Chapel Street. Until the beginning of the nineteenth century this hillside, rising up from Well Street and Leeds Road, was an area of open fields dissected by two ancient highways.

The Leeds turnpike intersected by the steeply ascending Church Bank and the meandering Vicar Lane was an ownership boundary between the Vicarage Trust lands to the east and the extensive estates inherited by the Revd Godfrey Wright to the west.

Chapel Street, East Parade (formerly Charles Street), Vicar Lane, Peckover Street (formerly Church Street), and Harris Street were all established by this time, with Vicar Lane and Church Street (Peckover Street) being the oldest roads in the area. Buildings were largely based on the pattern of fields and route-ways of that time.

In 1825 the original Eastbrook (Methodist) Chapel was built on land purchased from Harris. This was replaced in 1903 by the Edwardian Eastbrook Methodist Hall in Leeds Road designed by W. J. Morley. In 1832 a Quaker School was built in Chapel Street, to the rear of Eastbrook Chapel, and, in 1837, almost opposite, the very first Temperance Hall in England, the sites of both buildings being given by Harris. Until the 1850's the situation of Eastbrook House had been idyllic, with extensive parklands sloping down the hill as far as the present line of Peckover Street and with views across to the rapidly growing town.

In 1846 the area now known as Festival Square was part of a small wooded plantation on the Eastbrook Estate. Before the completion of neo-Gothic/Italianate warehouses built for wealthy German/Jewish merchants on remaining blocks of land, the area which later became known as 'Little Germany' included a range of existing warehouses, schools, community venues etc. The houses in Peckover Street and Chapel Street were homes to middle and working class people. There were five non-conformist chapels, schools and three hostelries. Jones's Mercantile Directory of Bradford from 1863 still shows a predominance of wool merchants, stuff manufacturers and spinners in the area, seconded by an assortment of shopkeepers and tradesmen/women.

In Hall Ings there were fifteen stuff manufacturers and worsted spinners; seventeen wool and yarn merchants; one engraver and printer, one Registrar of Marriages, one architect (Eli Milnes, the famous designer of many palatial buildings built after 1863). In Vicar Lane there were four stuff merchants; one dyer and one Whitesmith. In George Street were twenty-two shopkeepers including newsagents, grocers, butchers and beer retailers, one cabinet maker, two fent dealers, two boot and shoemakers, one

straw bonnet maker, one insurance agent, one innkeeper, two hairdressers and one tailor. In Harris Street were two dressmakers, two physicians, one wheelwright, three shoemakers, and one undertaker. In Peckover Street were five yarn, stuff and wool merchants, one plasterer and whitewasher, one joiner, one tailor. In the 1881 census, residential housing was noted at Nos 44, 42, 40, 38 (part of Bethesda Chapel), also Nos 2, 3, 5, 8, 10, 12, 13, 14 and No. 15 was the Old Park Hotel.

In Church Bank there were twelve wool merchants, two plumbers, one tailor, one joiner and builder, one upholsterer, three engravers and stone workers, two coach builders. In Barkerend Road was one painter, three butchers, two flour and corn dealers, twelve shopkeepers, two innkeepers, one hairdresser, one cab proprietor, one linen draper, one shoemaker, dressmaker, one chair and sofa maker, one solicitor, two tailors, one milliner, one bag and sack maker, one chemist, one plumber. Nos 2 and 4 Barkerend Road were listed as residential housing for tradesmen and their families.

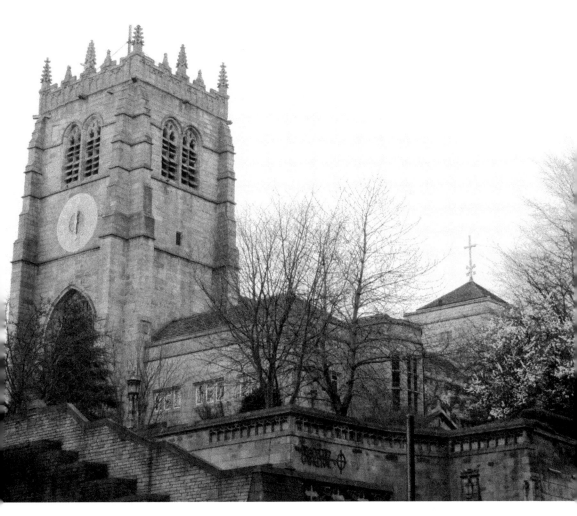

Bradford Cathedral, Church Bank. Image © Betty Longbottom.

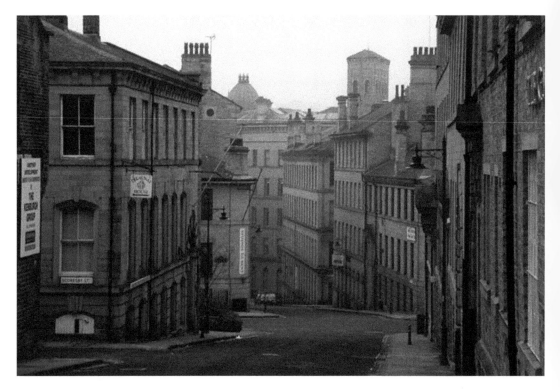

In Burnett Street were recorded six yarn and wool merchants. © Chris Allen licensed for reuse under Creative Commons Licence.

In 1921 Bradford Playhouse, on the corner of Leeds Road and Chapel Street, became the new headquarters of the Independent Labour Party and was renamed Jowitt Hall. Within the next decade the initial verve and enthusiasm demonstrated by its original pioneers had begun to wane. The building became used less for political purposes and more for public meetings and social gatherings. In 1933 the I. L. P. sold the hall to the Bradford Civic Theatre of which the famous Bradford author, J. B. Priestley became President and remained President until his death in 1984. His sister Winnie, who had been the Secretary of the Bradford branch of the Leeds Civic Theatre, went on to serve as Secretary to the independent Bradford Civic Theatre, and is commemorated by a plaque in the theatre.

In 1934, Priestley wrote of the Bradford Civic Theatre in his book *English Journey*,

Bradford has a Civic Theatre, of which I happen to be President [...] Even now, many people do not realise that there is a chain of such theatres, small intelligent repertory theatres organised on various lines, stretching across the country. Most of them have to struggle along [...] this dramatic movement [...] is of immense social importance. To begin with, it is a genuine popular movement, not something fostered by a few rich cranks. The people who work for these theatres are not by any means people

On the corner of Leeds Road and Chapel Street in Little Germany the Bradford Playhouse has a proud heritage, as a unique building with many of its historic features intact. On offer are a variety of events, such as theatre, film, music, exhibitions, comedy and dance. © Jaggery.

who want to kill time. They are generally hard-working men and women whose evenings are precious to them and they are tremendously enthusiastic, even if at times they are also like all theatrical folk everywhere – given to quarrelling and displays of temperament. These theatres are very small and have to fight for their very existence but I see them as little camp-fires twinkling in a great darkness. Readers may possibly not care two-pence if every playhouse in the country should close tomorrow. The point is that in communities that have suffered the most from industrial depression, among younger people who frequently cannot see what is to become of their jobs and their lives, these theatres have opened little windows into a world of ideas, colour, fine movement, exquisite drama, have kept going a stir of thought and imagination for actors, helpers, audiences, have acted as outposts for the army of the citizens of tomorrow, demanding to live.

The building burned down in April 1935. With help from Priestley, who donated royalties from several plays, the organisation bought the site and rebuilt. The new premises, a combined theatre and cinema called The Priestley, was opened by Sir Barry Jackson in January 1937. The company ran as an amateur theatre, with film showings between plays. The latter continued until 2001, despite having lost its status

as a regional film theatre a few years before, when the National Museum of Television, Film and Photography – now the National Media Museum – took over that role.

On the night of Friday 19 July 1996, the theatre had another major fire, but the company rebuilt the set in their Studio theatre so that the final show of the run took place. During the 1996/97 season, although the main auditorium was closed for reconstruction, a full season of plays was presented in the Studio. Then on Friday 31 October 1997 the main auditorium re-opened with J. B. Priestley's *An Inspector Calls*.

However, public interest in amateur theatre was unavoidably on the wane. By 2003, the theatre's finances had become critical. The current board of directors recommended that the company closed, but a rescue plan was accepted by the membership. The theatre's days as an amateur producing house were over, but it has continued as a receiving house, while the production function was devolved to a new company: Bradford ACT. The same fate met other aspects of its existence, such as its theatre school (once presided over by Esme Church and alma mater to actors such as George Layton, Gorden Kaye, Duncan Preston and Billie Whitelaw); such activities became independent of the theatre itself.

Bradford Playhouse was re-launched in October 2012 as a multi-disciplinary community arts centre, encompassing drama, music, film, dance and visual arts. The organisation's focus is community-led. The bar opens an hour before productions and then stays open until midnight.

The Quaker School, which is now a Community Centre, was originally located in Chapel Street and accommodated 470 children – 200 boys, 140 girls and 130 mixed infants. In Chapel Street there was recorded one whitesmith, bell hanger and gasfitter, one slater, one stuff merchant and in the census of 1880, domestic housing was also noted in and around Chapel Street. Over the years these were the homes of a cross-section of the community, from the humble artisans to people of professional status.

Round-headed windows in continuous moulded surrounds carried down to intersecting bar sashes are a unique example of this type of housing in Bradford. No. 18 has plate glass nineteenth-century sashes. Four stops lead up to panelled doors in end bay doorways. Semi-circular fanlights at Nos 16 and 18 match the intersecting glazed window patterns. These two houses were built in 1825 to house the ministers of the long demolished Eastbrook Wesleyan Methodist Chapel and are older than the surrounding warehouses.

Constructed sometime later, during the 1850s, Nos 20, 20a and 22, 22a were planned as four of the eleven dwellings built as 'back-to-backs' also Nos 24, 26 and 28 belonged to the row of two-bay, two-storey sandstone 'brick' townhouses, stepped in pairs. The thin horizontal part of the sash windows have since been altered or enlarged. These houses were usually occupied by members of the labouring classes, for example wool-sorters, curators, railway servants, etc.

The remaining seven were designed as 'through' dwellings and tended to be occupied by skilled artisans or people working within the professions, for example dressmakers, dyers, schoolmasters and doctors. These improved house designs allowed each householder to gain access to his house from the open street. A door at the rear

Photograph S Varo

Chapel Street (above)

These houses provide a good example of mid-Victorian speculative building. Chapel Street Nos 16 and 18 were constructed between 1840 and 1850 as a pair of three-bay, two-storey sandstone 'brick' town houses with molded stone-eaves cornice incorporating gutter and low-pitched slate roof.

of the building opened on to his own walled backyard in which was situated his own ash-pit and private privy. An alleyway at the rear facilitated the speedier and more hygienic removal of night-soil and other unwanted matter. These basic, but functional homes displayed little ornamentation. They were constructed in local quarry-finished stone, their plain appearance being interrupted by the simple two-pane sash windows allowing light and ventilation into each room.

The warehouses in Chapel Street Nos 30, 36, 38, 40 and 44 were built during 1870 to 1880 and are included in the book-chapter 'Little Germany after completion'. No. 14 Chapel Street was built in the mid-1860s and is probably an Andrews and Pepper design. This property was planned as a warehouse and office built on a narrow house plot in Little Germany. It has a tall four-storey ashlar sandstone front with Italianate classical details and a hipped (low) slate roof.

In Well Street there were twenty-five wool merchants (staplers), yarn and stuff merchants, two wool-mills (John Foster & Son, spinners and manufacturer and Titus

An unusual sculpture now adorns the upper end of Chapel Street, 'Grandad's Clock and Chair' by Timothy Shutter (1992). This is an amusing interpretation of a mill owner's office with a comfortable chair, mirror and grandfather clock. The work looks back to the past, but the swinging pendulum of the clock indicates that time does not stand still and the past has an important contribution to make to the future.

Salt, Son & Co. manufacturers and spinners of mohair etc.) one boarding house, Bradford Mechanics' Institution, nine shopkeepers, one shoeing smith, two plumbers, glazier and brass founder, one carting and coal agent, two innkeepers, one solicitor, one hay and straw dealer, one flour dealer, one baker, one (German) pork butcher, one pianoforte dealer, one bookbinder, one painter, one currier and leather cutter and two engravers and printers.

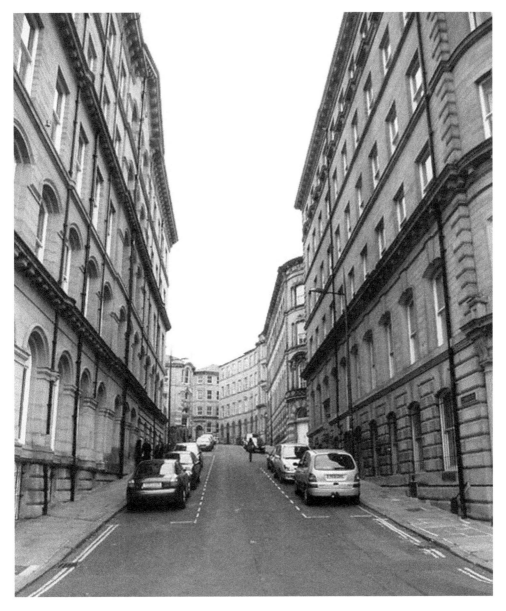

Currer Street takes you up into 'Little Germany' where all the Victorian warehouses are located. © Stanley Walker.

Paper Hall, Barkerend Road, Bradford, dated *c.* 1643 and restored around 1980–94 and now used as offices. A plaque records that 'James Garnett installed here the first Spinning Jenny in Bradford during the eighteenth century'. © Stephen Richards and licensed for reuse under the Creative Commons Licence.

In Charles Street, later East Parade, were nine worsted spinners and manufacturing mills, three commission agents and wool-staplers.

The Paper Hall on Barkerend Road is the oldest domestic building in the centre of Bradford, it was constructed about 1640 as a private house for William Rookes of Royds Hall, Low Moor. The building has had many owners and tenants but the most illustrious occupant was James Garnett who lived there from 1794 until his death in 1829. Garnett virtually inaugurated the Industrial Revolution in Bradford by installing in Paper Hall a number of hand-worked spinning machines, very likely the first use in Bradford of Richard Arkwright's new invention. It is likely that these would have been located in the loft and evidence has been found in the upper wing of such activity.

The name Paper Hall appears in 1756 when it was occupied by the Stansfield family. It could be something to do with textiles, the early use of fabric or wallpaper or

perhaps in association with the Roman Catholic Church, i.e. Papist Hall. The building shows an interesting mix of building styles appropriate for minor gentry. The house has a central body and two projecting wings. It is constructed in local sandstone which integrates well with the buildings of the conservation area, and built south-facing. The upper wing probably provided the better accommodation whilst the lower wing has been more modestly detailed to house servants. The interior of the building has since been modernised, without losing its character and historic context. Sadly, by the mid-nineteenth century the hall had fallen into disrepair and was described in 1841 by the historian John James as in 'a miserable state of dilapidation and neglect'. So it remained until 1972 when, threatened with demolition, a Bradford University professor, Jimmy Ord-Smith, raised funds to restore the building. Work was completed in 1994.

CHAPTER 6

THE MERCHANT WAREHOUSES OF LITTLE GERMANY

Serious development of Little Germany only began after Harris' death in 1847 (presumably Eastbrook House was then abandoned as a desirable residence) and within ten years this sylvan parkland had been transformed into an urban landscape. Commercial development reshaped the scene and by the middle of the nineteenth century, Bradford's industry had reached its pinnacle. The worsteds, mixed fabrics and silks produced by Bradford's manufacturers had become highly desirable clothing fabrics. This attracted a sizable continental market and German merchants in particular were keen to trade in the town. As the city centre was running out of space, these entrepreneurs established themselves in the undeveloped land to the south east of the church, which was in easy reach of both the railway station and the canal.

In 1848, the Public Health Act determined that 'no new house was to be built without proper drains' ('proper' being undefined) that 'sufficient water closet of privy accommodation and ash-pits, furnished with proper doors and coverings' must be provided. It appears that building permission would be given or refused according to the abundance of drainage and supplies of fresh air and little attention was given to the actual building plans or house numbers. Consequently, many of the original plans have gone missing, some drawn up on tracing paper have disintegrated, but those drawn on linen have fared better. It has to be pointed out that the plans are not and were never intended to be full architectural drawings and the limited purpose for which they were required must be appreciated. There is usually a plan of each floor of the building, the ground floor plan normally giving the name of the adjoining street and owners of neighbouring property. Detail is limited and, unfortunately, elevations were not required and so are not normally provided. Since the local authority was not concerned at that time with aesthetic considerations or the impact of a new building on the streetscape, the plans rarely show what a building actually looked like. The local authority was clearly more concerned at that time with basic matters of health and safety rather than the appropriate application of the Gothic or Italianate style. Also, despite the provisions of various Acts, street numbering on the earlier plans is almost unknown, which adds further limitations to positive identification of many buildings. Certainly none of the surviving plans for the warehouses in Little Germany carry street numbers and Bradford must still have been enough of a village in the

1850s and 1860s for such descriptions as 'a new warehouse in Burnett Street next to Mr Dunlop' to be sufficient identification.

Thus, 1850 marks the real beginning of a form of planning control at the local level and the 'notices' required by the council took the form of a building plan, which was deposited with them, titled 'Deposited Building Plans'. They gave in a manuscript note on the plans themselves, an indication of the type of property and a, often vague, reference, to its location, name of owner and architect and, of course, details of the drains. After perusal by the council they were countersigned as 'approved' or 'disapproved' and, if rejected, the reason was usually written on the plans by the Chairman of the delegated Committee. The plans are serially numbered in a simple chronological sequence. (Regrettably, during a transfer from the attics of City Hall to the care of the Archive Service in the years following 1974, many of the plans were found to have gone missing. Those which do still survive have recently been copied onto microfilm and are now available in the search room of the Bradford Archives. A bound Index, also on microfilm, was maintained which simply gives the street, building type, name of the applicant and the date of approval).

The Bradford Improvement Act took effect from 25 September 1850 and the Council lost no time in setting up its internal machinery to handle the new flow of business. A Street and Drainage Committee was established and among its special powers was the authority 'to approve or disapprove of the plans for the erection or rebuilding of houses'. This body settled down to its task with vigour, suggesting improvements for certain rebuilding, that 'each house must be provided with a privy in suitable situations.'[1]

By 1855 all the available building land in the town centre had been taken up and the hillside above Well Street and Leeds Road became desirable building land. Eastbrook House had already been abandoned as a prestige residence. At this time, spaces were at a premium and the only space available was a sloping piece of ground between the Parish Church and the Leeds Road, near to both of Bradford's railway networks.

Throughout the nineteenth century it was customary for English people of all social classes to rent their houses and business premises. Many warehouses in Little Germany were built on speculation and from 1855 onwards, the enormous profits made by local mill-owners were partly absorbed in new Bradford warehouses. Also, wealthy wool merchants were eager to impress customers, hence these wonderful Victorian buildings. These can still be seen throughout the city, especially in Little Germany, which is a fine example of a nineteenth-century merchant's quarter with an impressive collection of Italianate palazzo style warehouses. They form a collection of eighty-five buildings constructed between 1855 and 1890 within a very narrow margin of time and thus display similarity in materials, period and style, yet have very individual detailing.

In 1856 Thomas Dixon set out the street lines on the Vicarage lands, the cul de sac east of Vicar Lane, Burnett Street and part of Currer Street. These streets are only 12 yards wide from building to building, a concession of only 2 yards on the Hall Ings development carried out twenty years earlier, although in this period warehouse heights had grown from 28 feet to over 50 feet. By 1875 rigorously-enforced Bradford bye laws demanded 20 yards for cottage property, fully sewered, flagged and paved

before building commenced. It is unfortunate that a more comprehensive plan for the area, which would have involved the co-operation of Charles Harris' trustees, was not obtained at this stage.

Therefore, the reason for the narrow streets of Little Germany appears to have been that their total cost had to be met by the purchasers. For example, the warehouse at 40 Chapel Street has a site area of 3,000 square feet but this represents only 56 per cent of the plot paid for by the developer, the other 44 per cent being accounted for by the adjacent highways.

On further examination of contemporary maps, it seemed that buildings in Little Germany were erected at random until the French Commercial Treaty of 1860 brought a tremendous boost to trade and building activity.

The use of traditional building materials, the locally quarried honey coloured sandstone, lends a harmonious image and contributes largely to the character and overall unity of the area. Most of the buildings followed the stylistic trend set by Andrews and Delauney in their 1852/53 design for the Milligan & Forbes Home stuff warehouse in Hall Ings are now the offices of the Bradford Telegraph & Argus. Only two surviving warehouses depart from this generally-accepted style; George Corson's splendid Scottish Baronial for William Dunlop at No. 46 Peckover Street and the wildly extravagant 51/53 Well Street. They were designed by the best local architects of the day.

The average building cost in Little Germany at that time was £2 per square yard of rentable floor area, exclusive the cost of the building site and rentals were around 3s 6d per square yard. During the Great Depression there was a tendency for rentals to fall whereby wool warehouse rents kept on increasing. It was said that only two commodities went up in price during the period in Bradford – wool warehouse rentals and high-quality Bradford stone.

The first warehouse which stands at the southern corner of Well Street and Currer Street was designed by Lockwood and Mawson and erected in 1855. Although it lacks the architectural splendour of many later warehouses, it is a very important building because it set the style for subsequently built warehouses.

Bradford textile warehouses can be grouped into three basic categories: wool warehouses, yarn warehouses and stuff warehouses; stuff being the contemporary term for worsted woollen cloth. However, here we should point out the difference between 'wool, 'yarn' and 'stuff' warehouses.

Wool warehouses can be recognized by loading areas, doors or bays at each storey for hauling bales of wool into the building and its vertical row of double loading doors beneath a short crane job projecting from the eaves. In the early nineteenth century the wool-stapler, who dealt in combing wools which he foraged throughout the country, played a key role in the rapid development of worsted spinning in Bradford. The spinner's activities were financed by the wool-stapler who gave up to six months credit, a practice subject to much abuse in the rising markets pre-1875. During the Great Depression when overseas wools began to flood into Bradford, the trade of wool-stapler became almost extinct and there was a growing tendency to combine wool buying with commission combing, which is probably the reason why the wool

warehouse is a rarity in Little Germany; there were only two purpose-built and a few others adapted from stuff warehouses.

Yarn warehouses were solely concerned with the export trade. 'Stuff' or 'piece' warehouses dealt with home and export trade including cotton goods manufactured in Lancashire and finished and exported from Bradford although the occupancy of many of these warehouses in Little Germany changed at very frequent intervals, some firms transferred to larger premises and many left the area altogether.

Yarn merchants were engaged in the foreign trade exclusively, an activity that became increasingly important in Bradford after 1875 with the growth of manufacturing industries in Germany, Russia and the USA. Most warehouses in Little Germany handled piece goods. Piece (or stuff) warehouses were subdivided into two distinct types; shipping (or export) houses and home trade houses. Stuff merchants handled not only the worsteds, alpacas, mohairs, silks and pile fabrics manufactured in the Bradford district, but also the specialized products of the whole of the West Riding; two-thirds of the textile output of which passed through Bradford houses. These included carpets, blankets, woollens of all grades, worsted coatings, trouserings and dress goods together with a wide range of cotton dress fabrics. Such items were manufactured in Lancashire but dyed, finished and mercerized in Bradford in very large quantities after 1895.

Viewed from the street there is nothing to distinguish the yarn warehouse from the stuff warehouse. Some firms did both a home and export trade, notably the great international house of A & S Henry who operated from gigantic premises in Leeds Road. Also, Kessler's Warehouse at No. 64 Vicar Lane, known as Albion House, were involved in the export of piece goods, yarns and tops but in these instances each department was kept quite distinct and carried on under separate management.

Woollen manufacturers usually sold their own goods; the woollen trade being largely a home trade. The function and layout of the home trade warehouse was basically identical to the shipping warehouse, starting with the reception of the unfinished cloth. After brief scrutiny, grey goods went straight to the dyer who operated on a commission basis. A shuttle service of dyers' carts plied at all hours for this purpose, so that the narrow streets of Little Germany were choked with vehicles.

The Victorian merchant was often a 'converter' who bought the cloth direct from the loom and took upon his own shoulders the full responsibility for dyeing, finishing, marketing, and very frequently for designing the cloth itself and therefore instrumental in promoting completely new fabrics.

In the home trade warehouse the principal rooms were always to be found at ground level which in practice meant climbing about eight steps from the entrance, since this slight adjustment of floor level meant a radical improvement in the cellar lighting. This arrangement ensured maximum floor area for showrooms and storage space in accordance with the very heavy stocks of goods carried by home trade houses. In contrast, the counting house of the shipping warehouse was inevitably on the first floor and approached by a handsome staircase within a circular, polygonal or rectangular vestibule depending upon the position and external design of the main entrance.[2]

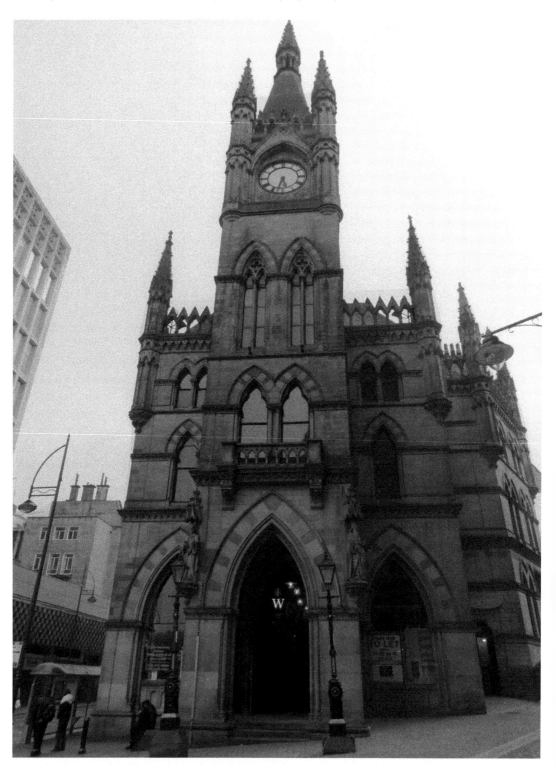

The Wool Exchange, Bradford © Stephen Richards.

The iconic building opposite reflects Bradford's growth from a provincial market town to a major industrial city. It was designed by Lockwood & Mawson, who had, almost inevitably, won the architectural competition amid a certain amount of controversy. Outside the Wool Exchange are busts of notable merchants, inventors and politicians, plus several New World explorers including Raleigh, Drake, Cook and Columbus.

Built between 1864 and 1867, while Bradford was still rapidly expanding, the building's elaborate design was a deliberate attempt to show the importance and wealth that wool had brought to the town. It was built in a mixture of Italian and Flemish styles. Many of the wool traders in Bradford at that time were Flemish.

In this then great mercantile town, many other textile firms had premises in the warehousing precincts. Each Bradford manufacturer maintained a twin office close to the Wool Exchange where travellers were dealt with on 'change' days, a direct approach to the mill being strongly frowned upon, although some manufacturers perpetuated the old tradition of renting piece rooms to display their wares. Accommodation was required for a multiplicity of commission agents, representatives, brokers and other middlemen, also connected with the profitable trade in Continental mule-spun woollen and worsted yarns, as well as Lancashire cotton yarns used by Bradford manufacturers and negotiated through spinners' agents. Many of these offices were in prestige buildings such as the Swan Arcade in Market Street, but there was a tendency to adapt badly-designed or inconvenient warehouses such as Austral House in Well Street.

Wool trading in the Exchange was carried out by verbal agreements, although traders had to register with a membership committee before they were allowed to work. Being a member of the Wool Exchange carried great social prestige in the city.

Wool trading stopped in the Exchange in the 1960s and the building is now a bookshop where original interior details can still be admired.

Unlike the Victorian worsted mill, where female and juvenile labour dominated the labour force, Bradford warehouses were all-male reserves sustained by cheap and compliant labour. Up to 1877, when it appears that a fifty-two hour week had become operative with overtime payable at 6d per hour, there were no established hours, the normal week being sixty hours or more depending upon the demands of the employer or the season fluctuations of trade which was particularly marked in shipping houses. The normal working day was from 6.00 a.m. until 7.30 p.m. on Saturdays.

In 1864 however there was a movement to place the 1500 Bradford warehousemen (including 400 boys) under the supervision of the Factory Act there was an immediate outcry and 1,200 of these warehousemen petitioned against the Bill, the general belief being that employers would dismiss all the boys. Another cause of irregular working hours in Bradford warehouses was the impossibility of examining pieces and carrying out colour matching without sufficient natural light, due to dense smoke pollution. When daylight failed this work had to stop, resulting in long delays during dark weather periods. When electric lighting was introduced in the form of high-power arc lamps, installation costs were extremely high. With this growth, the city expanded and the quality and style of new buildings became a source of great interest to authorities.

The elevations of buildings within conservation areas were traditionally unpainted and the stonework either hammer-dressed or ashlar. Ashlar stone was also used as

decoration around doors and windows on even the most modest buildings, whereas sandstone and gritstone setts and flags can be seen in areas of historic street surfacing. Stone slate roofs were popular for a small number of buildings constructed around the middle of the nineteenth century and blue slate for the roofs of most of the buildings built after the 1850s. Painted timber was popular for features such as traditional sash windows, panelled doors and in some instances guttering. Timber and stone was used for shop front details such as stall-risers, pilasters and traditionally glazed windows. Stained and leaded windows often reach up towards the upper storeys; there are also a number of stair windows and fan lights on a few of the buildings in Little Germany In Currer Street it will be observed that the corner entrances to most of the warehouses are incorporated in graceful curving motives (quadrants) whereas in Vicar Lane these smooth curves are replaced by straight lines (cants). The quadrant was in vogue up to around 1862, but after this date the more utilitarian cant became universal. The building arts survived the Victorian age but the proportion of expert stonemasons fell continuously, partly as a result of long and bitter strikes. This seems a possible explanation for the change from the curve to the straight line, since the stone dressing became considerable simplified.

In approximately 1858 a warehouse was built on the corner of Peckover and Burnett Street, now the site known as Festival Square, for two Scottish-born home-trade stuff merchants, Heugh, Dunlop & Co. In 1871 they transferred their business to 46 Peckover Street and the building was immediately taken by two German merchants, Rothenstein & Falkenstein. After fifteen successful years, they also moved to larger premises in Vicar Lane. The last company to own this property was W. Allen Corner Ltd, paper merchants. In the mid-seventies the building was extensively damaged by fire, which finally resulted in its demolition in 1979. The Council approached the owners of the site, W. Allen Corner Ltd, who gave their permission to use the land as a central square to be laid out as a focal point in Little Germany for social and leisure activities. It is now known as Festival Square. Although some of the wonderful architecture was demolished during the 1960s building and regeneration frenzy in Bradford, in the early 1980s, Bradford Metro Council set up an initiative to promote and revitalize the then depressed and decaying mercantile centre. With the help of local community groups, Festival Square was officially opened at the Little Germany Festival in September 1986 and a unique collection of eighty-five buildings constructed between 1855 and 1890 still remains to make up part of what is now a popular residential and business area. A number of unifying elements persist throughout the conservation area of Little Germany, but it is in no way uniform. The area can be classified into three character zones:

The Grand Warehouses

These are located together in the centre to south-western part of the area, along Vicar Lane, Aked Street, Hick Street, Cater Street, Currer Street, Field Street, Well Street and Peckover Street. This is by far the most memorable, impressive and dominating part of the conservation area. The buildings are typically four, five or six storeys in height

and individually designed with real architectural merit. They tower over the straight, narrow streets of the area, creating a very enclosed, shadowy space. The quality of this part of the town is accentuated by the use of York stone flag to pave the area, which integrates well in both colour and texture with the materials of the surrounding buildings. The rhythm of the fenestration of these grand warehouses is one of their unifying features and has come to form a principal component of the character of the place. Nevertheless, the architectural treatment of the window openings varies greatly from building to building, expressing the status of each structure. It is typical for the warehouses of this part of the conservation area to have inner yards, but these are largely hidden from view by large ornate wrought-iron or timber doors. The central routes of the area that would at one time have bustled to the sound of the coming and going of workers and produce are now relatively quiet and largely deserted for most part of the day.

The Small-Scale-Mixed Use Area

This is situated in the south-eastern corner of the conservation area is centred on Chapel Street and East Parade, two parallel streets that run up the hill.

Chapel Street is one of the oldest streets of the area and lined to the east with residential-scale buildings that predate the warehouses of the district. The character of this street is therefore quite different from the streets of densely packed warehouses. The lower height of these buildings allows more light into the area and gives it a much more open aspect.

Residential and community-used buildings predominate the area, which are interspersed with warehouse and factory buildings. An interesting small-scale stone building fronts Leeds Road, which has survived the establishment of Bradford Playhouse to its rear.

The types of buildings in the area clearly chart its development and the rapid change it underwent in the second half of the nineteenth century. Like the area of grand warehouses, the streets here no longer bustle to the sound of people and vehicles moving around the area. The more open aspect of the streets means that Shipley Airedale Road and Leeds Road have a more noticeable presence in this part of the conservation area. The sight and sound of passing traffic is evident from most vantage points and create a background hum to the area.

Smaller-Scale Warehouses and Factories

These are less ornate than those grand warehouses previously described. This area in the north of Little Germany developed later as an area of smaller-scale buildings with listed status and of historical and architectural interest in their own right. The style is generally less ornate. The sense of enclosure is not as great; buildings tend to be lower and consequently less domineering.[3]

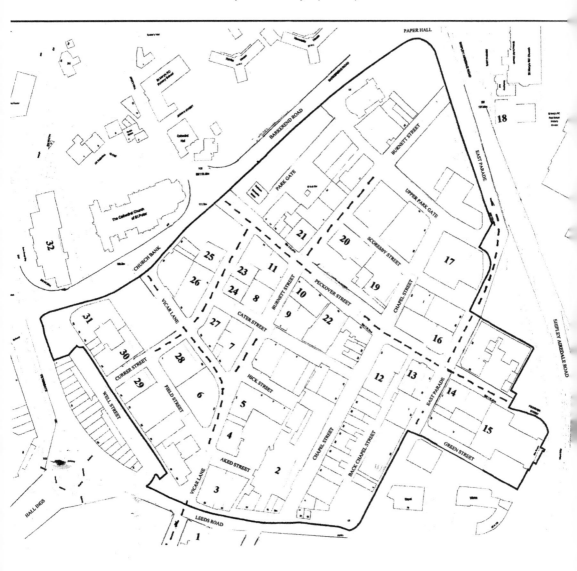

The most interesting of the above buildings are numbered on this map of Little Germany.

Description and occupancy of mercantile buildings in Little Germany.

1. Eastbrook Hall.
2. Stuff Warehouses, Nos 53–55 Leeds Road, corner of Vicar Lane.
3. De Vere House, No. 62 Vicar Lane, includes 1 Aked Street.
4. Albion House, No. 64 Vicar Lane, 1867–68 (two warehouses; second entrance in Hick Street).
5. Law, Russell & Co's Warehouse, No. 63 Vicar Lane: corner site with Field Street.

6. Priestley's Ltd Warehouse, No. 66 Vicar Lane corner site with Burnett Street.
7. Gallon House, No. 1 Burnett Street.
8. Stuff Warehouse, No. 5 Burnett Street; corner with Peckover Street.
9. Atomik House Nos 4-6 Burnett Street.
10. Stuff Warehouses, Nos 36, 38 and 40 Chapel Street.
11. Heugh, Dunlop's Warehouse, No. 46 Peckover Street.
12. S. L. Behren's Warehouse, No. 26 East Parade corner site with Peckover Street.
13. Sion Baptist Chapel, Green Street/Harris Street.
14. Caspian House, No. 61 East Parade.
15. Grattan Warehouse, No. 67 East Parade.
16. St Mary's R. C. Church, East Parade.
17. Moser & Edelstein headquarters, Merchants House on Peckover Street.
18. Wacorn House, No. 8 Burnett Street corner site with Scoresby Street.
19. Pickwick House, No. 17 Peckover Street.
20. Peckover Street, earlier Bethesda Chapel.
21. Victor House, No. 10 Currer Street.
22. Stuff Warehouse, No. 8 Currer Street; corner site with Cater Street.
23. Stuff Warehouse, No. 13 Currer Street.
24. Hospital Fund Building, No. 72 Vicar Lane.
25. Stuff Warehouse, No. 68/70 Vicar Lane; corner site with 6 Currer Street.
26. Downs Coulter's Warehouse, No. 4 Currer Street, with fronts to Field Street & Vicar Lane.
27. Stuff & Wool Warehouse, No. 47 Well Street incl. 2 Currer Street; extends to Field St.
28. 45 Well Street includes 1A Currer Street.
29. Pennine House, No. 39 Well Street; corner of Well Street and Church Bank.
30. General Post Office Forster Square.

Eastbrook Hall

Eastbrook Hall was built as a Methodist Central Hall and became known as the 'Methodist Cathedral of the North.' Once an octagonal preaching hall outside which Bradfordians used to queue on Sunday nights, it was first opened in 1904 but became vacant by the 1980s. A major fire in 1996 turned this once impressive Bradford historic building into a blight on the landscape.

In 2002, 'The Prince's Regeneration Trust' was asked by the Little Germany Urban Village Company to become involved with the restoration of Eastbrook.

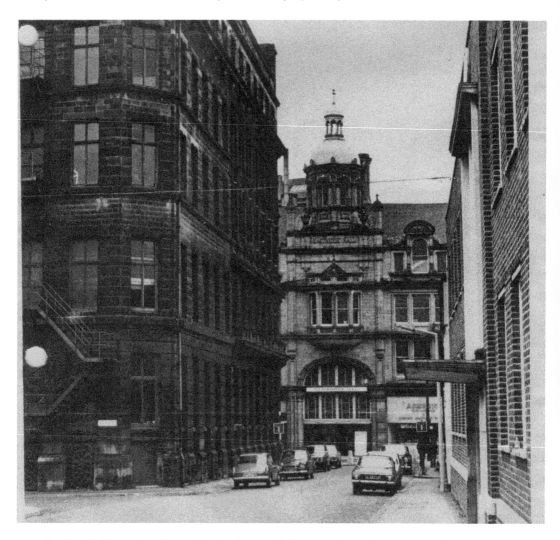

On the left, No. 62 Leeds Road & Eastbrook Hall as seen from George Street.[4] Its appearance was drastically altered by the addition of another storey in 1926. The basement window grilles and the linked block incorporating shops still retain their original Victorian windows. It now occupies the Job Centre.

'We explored how to provide the building with a new viable future that would protect the historic fabric while boosting Bradford's economy. It was hugely important that we looked at the wider area and ensured there was cross-sector collaboration in the project which would spur wider regeneration.

'We worked with Bradford Centre Regeneration, English Partnerships, Bradford City Council, Regen 2000, Yorkshire Forward and Aldersgate Estates. Despite being derelict, Eastbrook Hall was still one of best loved landmarks in Bradford. It was of real local significance when the Hall was reopened in November 2008 by our President, HRH The Prince of Wales.'

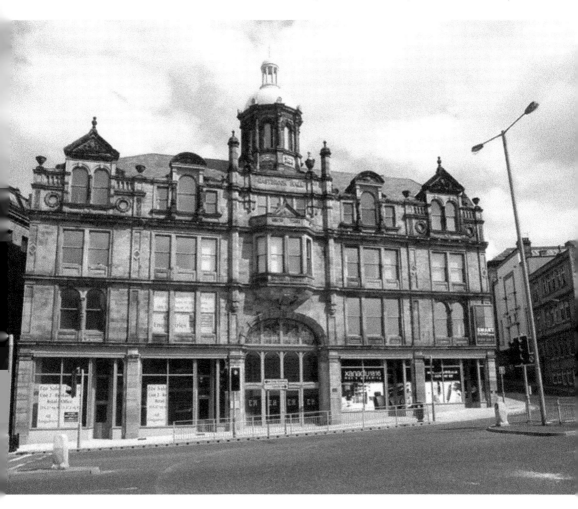

Eastbrook Hall Image taken from the Geography project collection. © Stanley Walker and licensed for reuse under the Creative Commons Licence.

The restored hall now includes over seventy apartments arranged around a central courtyard. There is also retail and commercial space, supporting local businesses. One of the real delights of the project was discovering Victorian stained glass, and we worked with local craftspeople to have the glass fully restored.

The original Eastbrook Chapel in near Gothic style, was opened in 1825 at a cost of £8,000 with seating for 1,500 persons. The window glazing of this charming building situated further back from the road, was reproduced in two houses built for visiting preachers in Chapel Street on land bought from Charles Harris for 9s 6d per square yard in 1935. These windows are still intact at No. 16 Chapel Street.[5]

Stuff Warehouses Nos 53–55 Leeds Road, Corner of Vicar Lane, by Eli Milnes, 1857; for W. M. Carver of Manchester

This warehouse, which is now known as Sunrise House, was built in two phases; the tower, the top of which is quite ornate, marks the junction.

By 1935 the flagstone of local quarries had already paved many of London's streets before Twenty-five years later, Bradford's streets were paved with local stone. Until

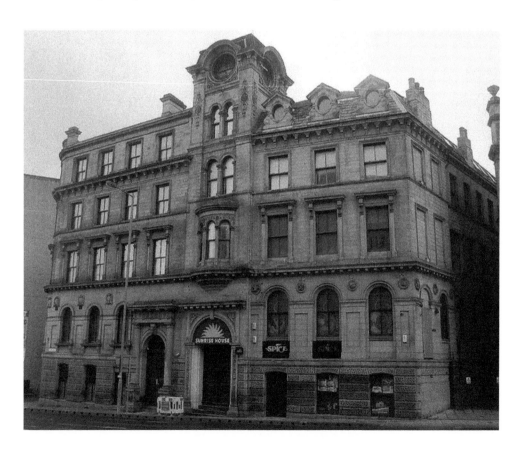

1865 most of Bradford's quality buildings were built from stone quarried in Leeds and it was Leeds craftsmen who stone-carved the two splendid and contrasting doorways, the fascinating circular medallions on this building. Partial concealment of the carved angle pilaster of the clock tower indicates that in 1875 an extra storey was added to fifty-three, Leeds Road. Roof-raising was once a common operation and screw jacks were already mounted beneath the roof trusses during the initial construction in case an extra storey would be required at some future date.

De Vere House

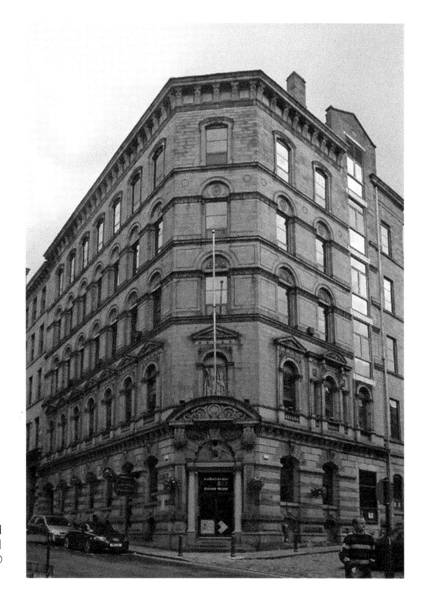

De Vere House, No. 62 Vicar Lane, includes No. 1 Aked Street, by Lockwood & Mawson 1871. © Stephen Richards.

This is probably Little Germany's second-grandest warehouse with exquisite Italianate detailing, especially noteworthy for the canted corner. A grand commercial palazzo with richly-modelled yet carefully proportioned elevations, form a corner block with Aked Street. It is built from sandstone 'brick' with ashlar dressings; five graded storeys and imposing masonry.

The impressive entrance shows good iron grilles and decorative touches which are absent from similar buildings, such as pedimented windows and decorative bands. The ground floor is arcaded with a waggon-way contained in the wider end bay. Inside, behind the corner entrance is the stairway, octagonal in plan with moulded soffits to treads, cast iron column banisters and swept and ramped handrail. The intricately-patterned stone archways above ground-floor windows are a typical feature of Francis Lockwood's buildings.

This beautiful warehouse was built for Thornton, Homan and Co., a firm of shipping and commission agents. Their monogram, TH, can still be seen over each second-floor window. The massive eagle over the impressive doorway and the medallion motif of stars and stripes in the first-floor window-heads, proclaim their important American connections. They also had a vast trade with China as well as America, largely in camlets, a valuable dress fabric of one colour into which designs were stamped using a difficult technique of water and hot presses, giving the cloth a smoothness and lustre. It is believed, however, that Hezakiah Thornton invested his money in this building as a purely speculative venture, as he already had business interests as a herbalist, fishcurer, fishmonger and bath proprietor when Gilson Homan was already trading as a stuff merchant. According to the 1871 Street Directory the company was registered as Gilson Holman & Co., stuff merchants. In 1872 the premises were occupied by the worsted coating and woollen manufacturing company of Edelstein Moser. It is now known as Devere House and is home to Bradford's Chamber of Commerce.

Albion House, No. 64 Vicar Lane, by Milnes & France, 1867–68

This is made up of two warehouses and the second has an entrance in Hick Street. Both warehouses are severe in style with identical frontages in Vicar Lane and Nos 2 and 4 Hick Street, built with sandstone ashlar with fine geometrical patterned iron gates similar to gates at the far end of Hick Street.

Buildings such as this tall and austere former warehouse help to create the special atmosphere of the narrow streets of Little Germany. These were once the premises of the Kessler family, wool merchants from Frankfurt, one of the earliest bulk importers of West Riding textiles into Germany. They opened a warehouse in Forster Square before moving in 1867 to the newly constructed warehouse in Vicar Lane. Kesslers had originally started in business as stuff merchants, exporting a considerable amount of their stock to the American markets. By the 1880s they had begun to diversify and develop an export trade in tops and noils, further extending their business into wool merchanting in 1909. This diversification of textile products was a result of the fall in demand by foreign markets for finished textile goods due to an increase of cloth manufacture overseas.

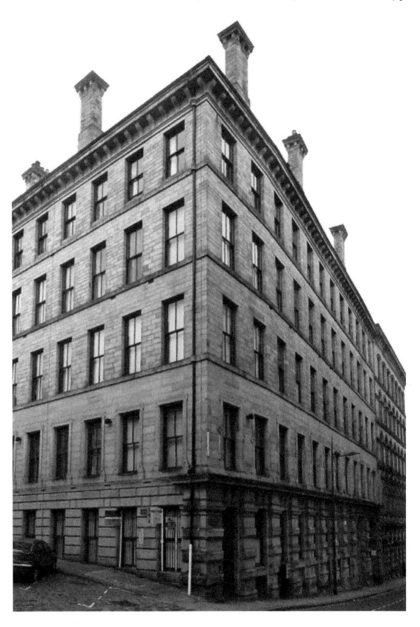

© Stephen
Richards.

The Kessler family was never personally involved with the Bradford Company. The first manager to take control of the business was J. E. Wiechers. After his death he was succeeded by his son-in-law Hermann Averdieck, a native of Hamburg. While residing in Bradford he became a well-regarded member of society with interests in the cultural development of the town. He was involved in the promotion of the Hallé Subscription Concerts and elected president of the Bradford Festival Choral Society. After his death, a ward at the Bradford Eye and Ear Hospital in Hallfield road was named after him as a memorial.

Law, Russell & Co's Warehouse, No. 63 Vicar Lane

This is by some distance Little Germany's grandest warehouse, its extravagance is quite out of keeping with the rest of the area. This distinctive home-trade warehouse building is one of Britain's outstanding Victorian warehouses and the finest edifice of its type ever to be erected in Bradford. The five-storey sandstone 'brick' building with ashlar dressings was built on the only level site available in the home-trade precinct of Leeds Road. The display is reserved for the entrance bay at the apex of the building

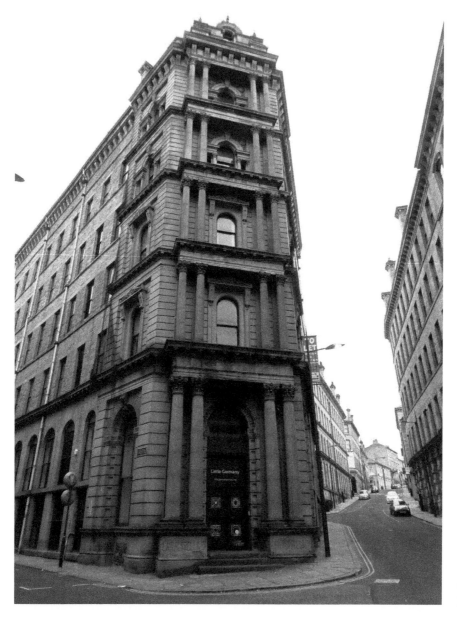

© Stephen Richards.

and takes the form of no less than five floors of paired Corinthian columns. There is a dome at the top and fine entrance gates in Field Street.

In 1837 John Russell, a Scotsman, formed a partnership with John Douglas and opened a home trade warehouse as Russell Douglas & Co. in Leeds Road. Upon the retirement of Douglas from the firm and his subsequent move to Scarborough, James Law, a fellow Scot, joined the business in 1842 as principal book-keeper, eventually rising to the position of senior partner. This warehouse was one of the last to be built in the relatively prosperous middle years of the nineteenth century.

The building was constructed in nineteen months by a Bradford-based Scotsman, Archibald Neil, who, it is said, used the most up-to-date techniques in building construction. He quarried and dressed his own stone and, whilst it was still green, cut the necessary slabs to the correct shape and size in the stone yard. When they were eventually brought to the site, every block was expected to fit into place.

The ground plan, almost in the form of a quarter circle, was dictated by the abrupt turn of Vicar Lane, with a width of only 28 feet between both wall faces. The top of the lavish entrance to this former warehouse is the pavilion form of five Corinthian porticos, a vital part of the building which not only disguises an equally magnificent spiral staircase, but skilfully integrates the seven-storey warehouse.

A singular feature of several of Bradford's warehouses is the decorative ironwork, in the form of gates and overthrow to the old cart entrance. This was not only the most architecturally extravagant building in Little Germany, but the last local assignment of the architect Henry Francis Lockwood. The front entrance of the Law, Russell warehouse, beneath its mighty portico, opened into a circular vestibule, 18 feet in diameter and set beneath a French-style circular dome complete with iron cresting, 108 feet above pavement level. Goods entering these premises were received in a private enclosure to prevent prying eyes from looking over the latest novelties. The enclosure was entered through a large warehouse gateway and the entrance passageway extended into a rectangular yard, protected by a glass canopy at first-floor level, into which came the undyed or 'grey' cloth direct from the loom for preliminary examination into the 'grey room' which took up a quarter of the ground floor. Complementing the grey room on the ground floor was the packing room, concerned with the outward cycle of goods movement and equipped with powerful hydraulic presses. On its return from the dyer, the cloth was raised by steam hoist to the attic on the fifth floor, where most of the warehouse staff was in the making-up room. The cloth was first inspected by a 'percher' who pulled the finished pieces over a roller placed above and directly facing a well-lighted window to detect flaws or uneven patches so that appropriate instructions could be given to the mender or dyer. Then followed the measuring, rolling or folding operations; each carried out by ingenious steam driven machinery. The pieces were put into stock in open cabinets on the first, second, third or fourth floor according to their category. The fourth floor, which was the full size of the ground plan of the building and completely free from shelving and fittings, apart from polished birch counters, was used for laying out incomplete orders. The total length of polished counters (completely intact until 1976) was 1,900 feet or 580 metres. A portion of the third floor was used as a sample room, the rest being covered with shelving for woollen goods, linings and

umbrella cloths. The counters and fittings of this and all the other floors below were finished in highly-polished mahogany. The second floor was appropriated to cotton, worsted silk damasks and other fancy and novelty goods, whilst the floor below was reserved for plain goods of the traditional Bradford trade.

Daylight filtered through a large round dome light which illuminated a magnificent stone spiral staircase with a heavy oak balustrade extending to the summit of the building. In the design of this magnificent warehouse great emphasis was placed on the quality of natural lighting throughout the building. On the first floor and above, the light from the windows of the outer walls was supplemented from two other sources. Additional windows on each floor faced three sides of a rectangular yard. To improve the lighting further, the walls of this enclosure were lined by white glazed brick. The second, third, fourth and fifth floors had 16-feet-square openings beneath a roof clerestory of similar size. The feature was known as a well-light but its presence greatly increased the fire risk, since the internal construction was of timber. For this reason alone, it was never incorporated in warehouses designed by Eli Milnes who relied exclusively on the yard-light method.

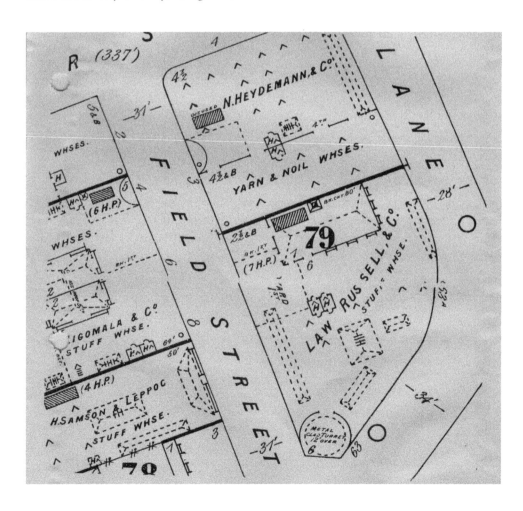

At left is a section of Goad's Map from 1886 illustrating the methods of lighting the Law Russell Warehouse. The four skylights shown by broken lines illuminated the attic only. The almost square well-light is marked with four dashes indicating openings through floors.

At each landing, the original doors and window sashes were of solid oak relieved with ebony whilst the ornate gas brackets were of solid bronze. Victorians, rich or poor, were expected to walk up and down staircases; lifts being reserved for goods only. The front stairs were out of bounds to all but senior staff and potential customers. At ground-floor level, immediately in front of the entrance and between a small Enquire office and the office of the Grey Room manager, was the Counting House, sumptuously fitted out in Honduras mahogany for its staff of sixteen clerks. Discreetly tucked away behind this impressive room, aglow with rich woodwork, was an elegant dining room for the directors and selected clients. In the basement were the boiler (from which ascended a very large chimney), the steam engine and a coal storage unit together with a kitchen, a workmen's dining room, an auxiliary Grey room and a blanket store. (Blankets became part of the stock in trade of Bradford warehouses in the early 1860s about the time of the American Civil War. During the Russo–Japanese War of 1904–1905 a large proportion of the blankets for both groups of combatants were supplied by Law Russell and Co.)

Priestley's Ltd Warehouse, No. 66 Vicar Lane Corner Site with Burnett Street, by Eli Milnes, 1866

This is part of a block of wool warehouses built in 1866 on a corner site with Burnett Street. Between 1870 and 1900 this warehouse was occupied by four different companies. The first to take the premises was Jacob Philipp & Co., of which little is known. In 1884 the German mercantile company of Hermann Samson & Leppoc were in residence until 1886, when the newly formed company of Rothenstein & Falkenstein traded from the building. In 1890 these premises were acquired by Briggs, Priestley & Sons, who, like many other manufacturers during the Great Depression, cut out the middleman and began to market their own goods utilizing the famous trademark 'The Varnished Board' referring to the rolling board on which the finished cloth was wrapped.

Priestley's Ltd, as the firm became known in 1901, was noted throughout the world for their dress fabrics and was able to keep 1,200 employees at work when many of their rivals were in chronic decline. Woollen yarns and warps were imported from France for the production of lightweight, all-wool fabrics. Due to the lack of confidence in local dyers many British manufacturers of this class of goods sent them for dyeing and finishing to Paisley or France, but all Priestley's cloth was sent to Bowling Dyeworks.

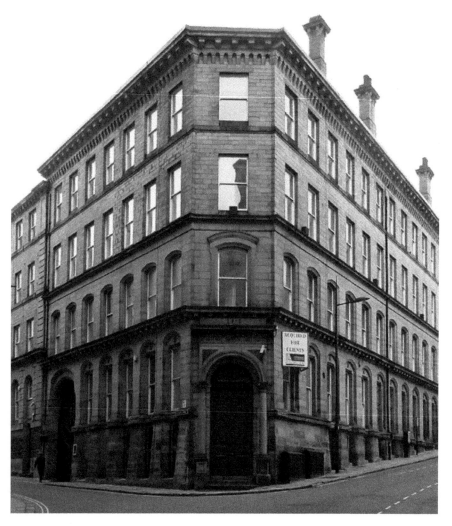

Warehouse Priestley's Ltd, No 66. Vicar Lane/Corner Burnett Street.

Gallon House, No. 1 Burnett Street, by Milnes & France, 1866

The plot of land on which this warehouse is built was sold by the Revd John Burnett, Vicar of Bradford, to William Schaub, a German stuff merchant. This six-storey warehouse building with semi-basement is built of finely-dressed ashlar sandstone. The monogram over the doorway depicts the owner's initials and surmounted on either side by ships' anchors, presumable to denote his connections with overseas trade.

William Schaub, born in 1825, was a native of Baden-Baden. It is recorded that in 1856 he had established a small business in Bradford in Norfolk Street. In 1863 he is registered as a stuff merchant in Chapel Street. In 1872 he transferred his business to Burnett Street, where he remained until the turn of the century.

© Stephen Richards.

In 1912 the building was under the new ownership of L. N. Hardy & Co., stuff and woollen merchants, run in joint partnership between Hardy Behrens and Lawrence Von Hallé. It is believed that the ancestry of Hardy Behrens has an indirect link with the renowned Sir Jacob Behrens. Lawrence von Hallé was a known and respected member of the Jewish synagogue on Bowland Street.

In 1988 the building which was owned by Standard Electrical Cables and used for the storage of electrical components, then by Malcolm Judson, managing director of a York based construction company. After extensive renovation and refurbishment, the original old stuff warehouse was converted into a modern hotel providing budget accommodation. However, it has since been refurbished into rental apartments.

Stuff Warehouse, No. 5 Burnett Street, by Eli Milnes, 1858

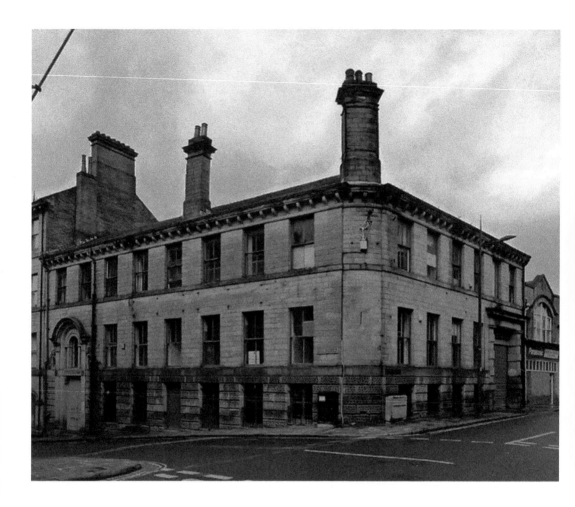

The first merchant to occupy the premises of No. 5, Burnett Street was Julius Delius, the German stuff merchant and father of the composer Frederick Delius. He set up business as stuff and noil merchant in 1858 and continued to trade from these premises until 1874, after which he moved to a larger and newer warehouse in East Parade. When Delius transferred his business, the premises were then taken by a fellow German, Moritz Kaufmann, a stuff and woollen merchant who had established a business in Manchester and arrived in Bradford in 1863. After approximately four years in the warehouse, Kaufmann vacated the building. In 1883 it was taken over by Denison Wens & Co., yarn merchants. The German occupation of this warehouse terminated in 1886 when Arthur Walker & Co, a Bradford-based company of stuff merchants, took over the building. In 1912, George Walker bought the premises and set up a printing works and in 1965 the printing business was under the ownership of James Buckroyd.

Atomik House Nos 4 and 6 Burnett Street, by J. T. Fairbank, 1859

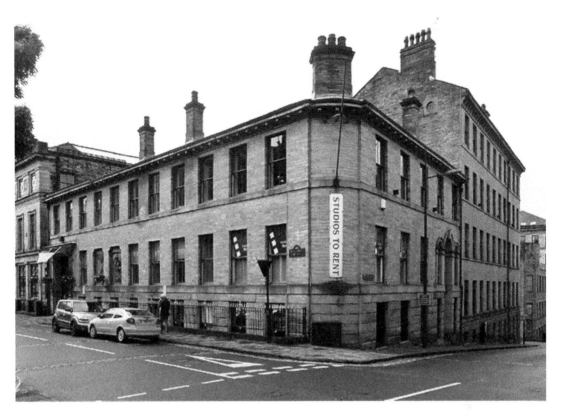

This is a plain, lower-rise, two-storey office/warehouse corner block built out of sandstone. Five sash window bays face Burnett Street and No. 11 Peckover Street. The basement has a half storey on Burnett Street due to the slope. The rough surface of the doorway ensemble, in comparison to the opposite building (No. 5 Burnett Street), is due to the nature of the flinty silica sandstone. David Julius Heyn, the yarn merchant who built this warehouse, had an important Russian connection and in 1884 became associated with a large spinning mill which opened near Warsaw. This building is now the Bradford Design Exchange, further modernized as an art gallery and design studio. © Stephen Richards.

Stuff Warehouses Nos 36, 38 and 40 Chapel Street, by Andrews & Delaunay, 1871

No. 40, on the corner, dates from 1860 and Nos 36 and 38 from 1871. All have similar decorative entrances but have since been converted to flats – hence the modern intrusions.

This is an important corner site of large four-story warehouse/office blocks with partial basements. No. 38 is matched to the adjacent buildings (Nos 36 and 40 Chapel Street), even to the identical carved monogram which in each case obscures a large area of the semi-circular fanlight, it is however one storey taller. It has a hipped roof

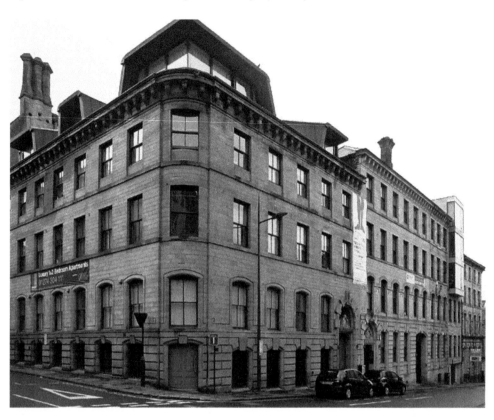

© Stephen Richards.

(sloping gable) facing Chapel Street and linked to four short gabled roofs visible from the rear. There is a three-storey open ground floor extension linking with No. 30.

Inadequate loading facilities in the narrow Back Chapel Street emerge into Leeds Road through a passageway. This warehouse, like some others in Little Germany, still retains the two-pane sash window commonly associated with mid-Victorian dwelling houses. This building is now named Hanover House and has since been converted into apartments.

Heugh Dunlop's Warehouse, No. 46 Peckover Street, by George Corson, 1871

This majestic building, with its corbelled turrets, adds a unique touch of the Scottish Baronial into Bradford's warehouse district.

The firm of Heugh, Dunlop & Co, founded in the late 1850s, was a home trade house with Scottish partners, John Heugh who lived in Manchester and Walter Dunlop, in Bingley. Unlike most in Little Germany, this business served home markets only. Also, this building, designed by the leading Leeds architect, has a distinctively different design known as 'Scottish Baronial' – a style associated with old Scottish castles. The overall effect has been destroyed by the later addition of a tall and commonplace attic.

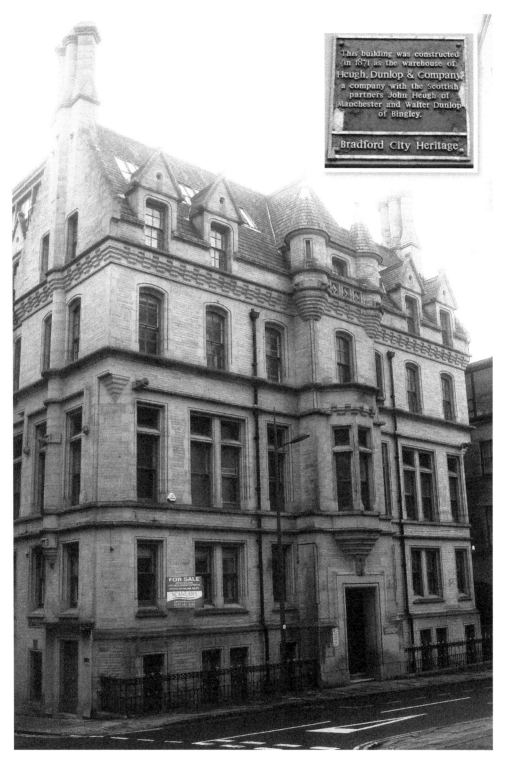

© Stephen Richards.

S. L. Behren's Warehouse, No. 26 East Parade/Peckover Street, by Milnes & France, 1873

When S. L. Behrens & Co. moved from Swaine Street into this enormous building (with a floor area of 5,400 square yards), trade was booming. They bought an almost equal area of land for future expansion. However, the warehouse was closed in 1877, so swift was the collapse of the German piece goods trade.

The size of the facades is relieved by a strong horizontal emphasis. The Gaisby ashlar sandstone from Wrose (Shipley) quarry, is of exceptional quality and an ideal basis for the Italianate style. The 120-feet frontage dominates with its rows of rectangular windows. First-floor windows are linked across rectangular columns by neat hooded moulds which are common to many of Milnes' buildings in Little Germany. The internal construction, standard in Victorian Bradford, is of timber. Archibald Neill, the contractor for the entire building, noted for its grandeur and use of iron decorative details. The tall Venetian chimneys are also of considerable merit, along with the details of the drain pipes as they pass through the stone string courses.

Sir Jacob Behrens was one of the most philanthropic merchants in Bradford and his name is preserved in the wrought iron screen above the wagon entrance. There is also a plaque on the wall in honour of Behrens.

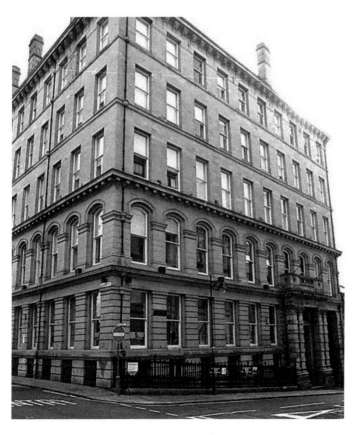

© Stephen Richard.

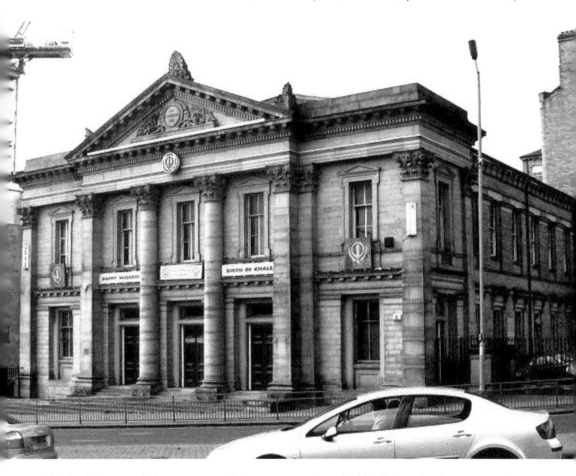

This building now belongs to the religious community of Sikhs, it is a Gurdwara, meaning 'House of God' and a Sikh place of worship.

Sion Baptist Chapel, Green Street/Harris Street by Lockwood & Mawson, 1873

This building replaced the first Sion Chapel which stood on the site of the new Exchange Station. It was sold at great profit, allowing the prosperous and rapidly expanding Victorian congregation to build new headquarters. Unfortunately, this building is not considered as being hugely successful, due to the negative effects of cluttering ornaments and friezes. Being unprotected from wind and weather, it is also prone to dampness. Change in the uses of religious buildings is not unusual in Bradford.

Caspian House, No. 61 East Parade, by Milnes & France, 1873

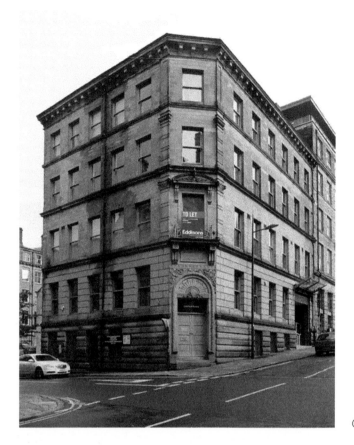

© Stephen Richards.

Detail of No. 61 East Parade, Bradford. A profusion of decorative motifs carved above the door of this building. © Copyright Stephen Richards.

This warehouse was erected by J. & W. Beanland for D. Delius & Co., yarn and stuff goods shippers, a more elegant building than Julius Delius' previous premises in No. 5 Burnett Street. This building has a very attractive cut-off (canted) corner which measures 8.5 feet in width; barely wide enough for the intricate door carving which extends over all the available surface.

The first-floor corner window has a wrought-iron balcony and richly carved gable. Highly decorative cast iron grilles protect basement windows. By 1870 the production of ornamental cast iron had developed into a specialized industry. Railings, grilles and intricately patterned roof-crestings could be obtained from a new generation of iron founders, the greatest name being that of Macfarlane of Glasgow.

A plaque records that No. 61 East Parade was restored in 2003 with the financial assistance of Regen 2000 and the Little Germany Urban Village Co.

Grattan Warehouse, No. 67 East Parade, Architect Unknown, 1913

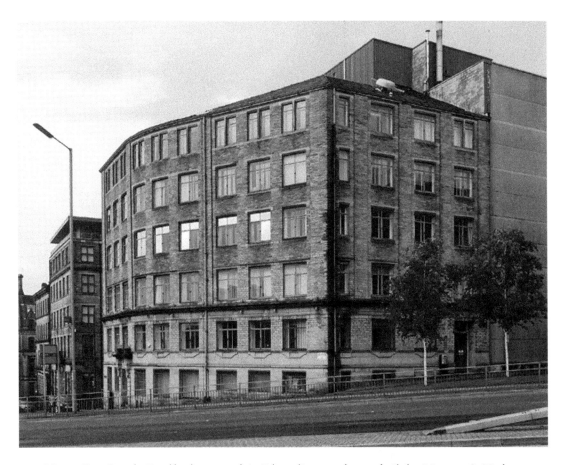

No. 67 East Parade, Bradford, a very plain Edwardian warehouse, built by Mawson & Hudson in 1913 © Stephen Richards.

This building was commissioned by Sharp, Sonnenthal & Co. who were specialists in the Far-Eastern trade. This workmanlike building is one of a limited number of stuff warehouses, built in Bradford between 1900 and 1916 after a total lapse of twenty-five years in this type of construction. The overriding impression as compared with the old-time warehouse is one of compactness; reduced room heights allow for additional storeys with 25 per cent more floor area than buildings of the same height. The vertical side of the doorway shows contemporary stone carvings which seem more reminiscent of fascist influence in the 1920s than the curves and scrolls of the previous century.

This site, as well as that of Behrens' warehouse, is now showing foundation issues due to the sporadic grubbing of coal from the Black Bed, an outcrop which was revealed in 1973 during the construction of a linked building.

St Mary's R. C. Church, East Parade, by J Simpson, 1876

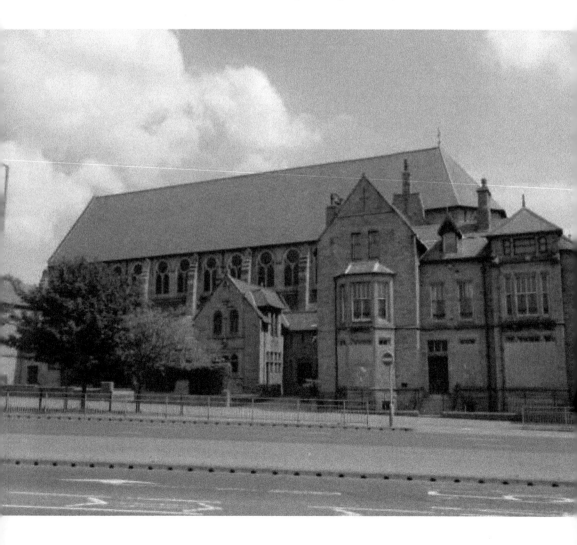

This plain but massive structure of St Mary's was built on a shoe-string by the sacrifices of the poor Irish immigrant Roman Catholic community. Devoid of external ornamentation, the building relies upon its boldness of outline and immense size for its architectural impact. There is an abundance of rust-faced walling stone, despised by the Victorian builder but destined to become a prestige building material in the 1920s. Two luxuries only were conceded; a splendid four-manual organ and a set of stocky cylindrical shafts of brown marble from the Emerald Isle for the nave arcades. The church body is unusually wide, the aisles reduced to mere passageways beneath lean-to roofs through the slate cover of which plunge the buttresses. This may be forgiven, considering value for money was the keynote of this notable design.

Moser & Edelstein headquarters, Merchants House on Peckover Street, 1902

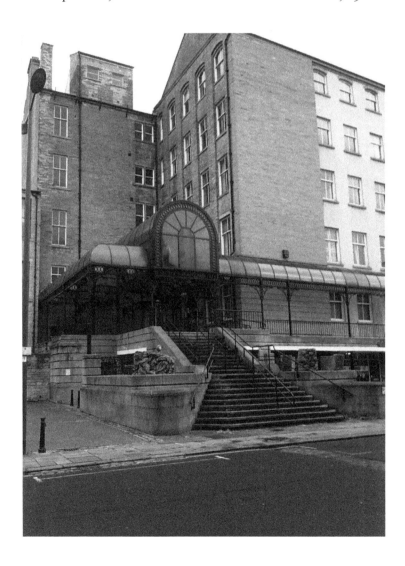

This was built in 1902 to the designs of Milnes and France for Victor Edelstein and Jacob Moser. Edelstein Moser & Co. was founded in 1872 as stuff merchants, later wool and yarn were added and the business became a leading shipping house and was based originally at Devere House. They moved to this purpose-built warehouse in 1902 and at the time the building was structurally innovative, constructed over an earlier open-cut coal mine and an open space, previously used for large-scale political gatherings.

The traditional cast-iron columns remained, but the usual floor beams were replaced by rolled steel joists increasing the fire resistance and load bearing capacity. The walls are built of roughly-dressed stone, the fashion for detailed ashlar having passed and larger windows also indicate less emphasis placed on the walls for structural strength. The elevation to Peckover Street has been totally remodelled for Bradford Council by the Saltaire-based firm of architects Rance Booth & Smith. The work was carried out in 1988 as part of the scheme to create managed workspace, with the emphasis on computer-based companies. The building has been totally reordered so that the main access is from Peckover Street and not as originally off Chapel Street.

Wacorn House, No. 8 Burnett Street, Corner Site with Scoresby Street, by Andrews & Delaunay in 1862

This small but exceedingly well-built warehouse was constructed for Hoffmann Hurter & Co., yarn merchants, later to become A. Hoffmann & Co., under the sole control of Achior Hoffmann. Hoffmann was to play a leading role on behalf of the Bradford Chamber of Commerce in preparing the groundwork which led to the opening of the Bradford Conditioning House in 1891. After his death in 1885 this important task was taken over by his son and business successor, Col G. J. J. Hoffmann, who was able to explain to Bradford Town Council in considerable detail that based upon the widest commercial and technical experience, how such an official control laboratory ought to function and what benefits might be expected for the Bradford textile trade as a result. The need arose because wool readily absorbs atmospheric moisture and this led to serious disputes between buyers and sellers regarding the true weight of consignments of tops, noils and yarns. Hoffmann told how many Bradford wool merchants were able to pay their warehouse rents by storing wool in 'very nice damp cellars'. The valuable advice was taken. Bradford's trade in semi-finished goods boomed and, more important, the seal of integrity of Bradford Conditioning House confirmed Bradford's status as the woollen capital of the world.

Carved on the doorway keystone of this warehouse is the caduceus, the staff used by the messengers of the Greek gods, around which is entwined two serpents, a device also to be seen on the 'Telegraph & Argus' building in Hall Ings. Since Hermes was the god of commerce and peace, the caduceus was taken as a symbol by international merchants.

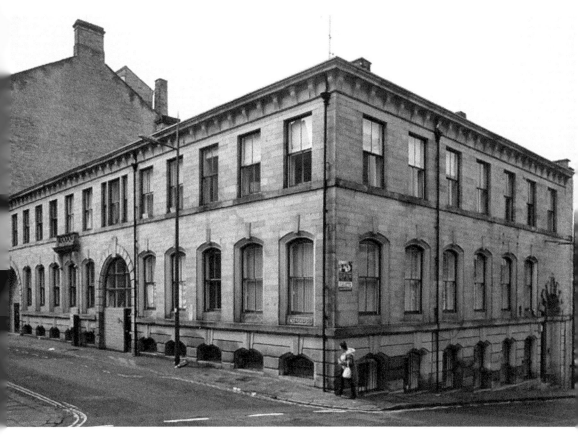

No. 8 Burnett Street, Bradford, a modestly sized warehouse endowed with a touch of extra grandeur by the simple means of moulded window surrounds. © Stephen Richards.

Pickwick House, No. 17 Peckover Street, 1856

A small warehouse designed for wool storage, featuring the hoist and taking-in doors facing Burnett Street. The building still retains the original six-paned sash windows. This warehouse is one of the very few in Little Germany shown on an early map of 1858, in the *Illustrated Commercial Guide for Bradford* issued by J. Curry. The earliest recorded occupants of the premises in 1863 were the German tenants Roper & Frerichs who traded there as yarn, woollen and worsted merchants. The partnership was dissolved in 1879 leaving Frerichs the surviving partner. Paul Alexander Frerich was born in Bremen, Germany. He established a business as a cotton spinner in Manchester. With the introduction of cotton warps in the weaving of mixed worsted cloth and the growth of mercantile interest in Bradford, his son Andreas Frerichs set up residence in the Claremont area of Bradford in 1872. The firm quickly became established as one of the first international trading companies in the area, attaining very strong business connections with large textile mills owned by Baron Kroop in Russia. It is also known that they did business with several American companies.

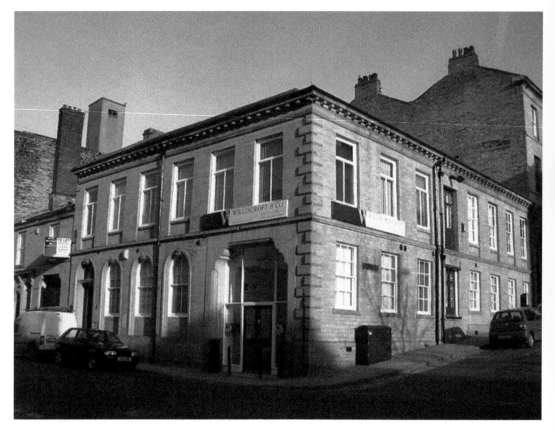

Pickwick House, No. 17 Peckover Street. © Stephen Armstrong.

Peckover Street, earlier Bethesda Chapel

The second half of the nineteenth century experienced a strong revival of evangelicalism in the West Riding and none was more vigorous than the Wesleyan Reform Movement. Facing Merchants' House, the frontage of this warehouse hides a longer history than would be expected. In 1855 plans were prepared by the architects Lockwood & Mawson for the erection of Bethesda Chapel on Peckover Street. It took fifteen years, however, before the chapel was officially consecrated for worship in 1879. It served the local community for approximately ten years only, the short existence being primarily the result of the occupants of the inner city dwellings gradually migrating to the newer housing developments which were being constructed on the outer fringes of the town. The disused building was quickly taken by another recently established church organization, The Salvation Army, and served as their Bradford barracks until around 1886.

Within the same year, the comparatively new Independent Labour Party took the rental of the chapel for a period of three years from the site owner James Drummond, a Manningham manufacturer, for £100 per annum. This radical party was officially

The Socialist Commandments.

1. Love your school-fellows, who will be your fellow-workmen in life.
2. Love learning, which is the food of the mind; be as grateful to your teacher as to your parents.
3. Make every day holy by good and useful deeds and kindly actions.
4. Honour good men, be courteous to all men, bow down to none.
5. Do not hate or speak evil of anyone; do not be revengeful, but stand up for your rights, and resist oppression.
6. Do not be cowardly, be a friend to the weak, and love justice.
7. Remember that all the good things of the earth are produced by labour, whoever enjoys them without working for them is stealing the bread of the workers.
8. Observe and think in order to discover the truth; do not believe what is contrary to reason, and never deceive yourself or others.
9. Do not think that he who loves his own country must hate other nations, or wish for war, which is a remnant of barbarism.
10. Look forward to the day when all men will be free citizens of one fatherland, and live together as brothers in peace and righteousness.

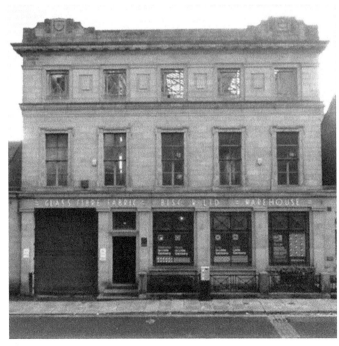

No. 36 Peckover Street. Earlier Bethesda Chapel and later headquarters of the Independent Labour Party.

launched at the Peckover Conference. Among the many socialists assembled at the inauguration were several notable personalities, including George Bernard Shaw, a delegate for the Fabian Society, Keir Hardie, founder member and chairman of the I. L. P. and Labour Member of Parliament for West Ham. Local interest was represented by Fred S. Jowitt, Bradford's first socialist councillor, who was eventually elevated to a ministerial position in the first Labour government. Upon the termination of the building's three year lease, James Drummond placed the premises on the open market for sale. In a determined effort to retain the property the I. L. P. issued shares, formed a limited company and bought the Peckover Street headquarters for £2,200. The building was known as the Labour Institute or the Labour Church. The religious connotations were aligned with the I. L. P's philosophy concerning the Brotherhood of Man and the vision of a New Jerusalem.

Victor House, No. 10 Currer Street, by Eli Milnes, 1862

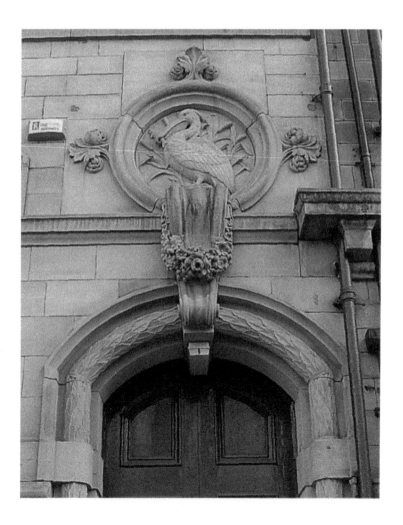

Little is known of the Manchester based firm of Dufour Bros who occupied these premises in 1866. An interesting feature of this plain warehouse includes the sculpture of a pelican above the door and prehistoric tree-like columns on each side, sometimes used in Christian symbolism to typify the Lord's redeeming work ... Perhaps a reference to the firm's religious and caring attitude to business? The basement of this building housed the yarn room, the packing room and a small boiler room. On the ground floor a large area of floor space was taken by the counting house, where clerks toiled over their ledgers, expenditure and financial balance of the company. Alongside the counting house was the Grey room, where the cloth was stored prior to being transported to the dye works. A small private office reserved for the warehouse manager was situated by the principal entrance. On the first floor were the cloth stock room, pattern room and show room. The top floor was allotted as the make-up room from where the customers' orders were measured, cut, folded, packed and dispatched. The plans also indicate that there was only one toilet in the building, being specifically for gentlemen, which suggests that warehouse work in Little Germany was male dominated.

Stuff Warehouse, No. 8 Currer Street, 1861

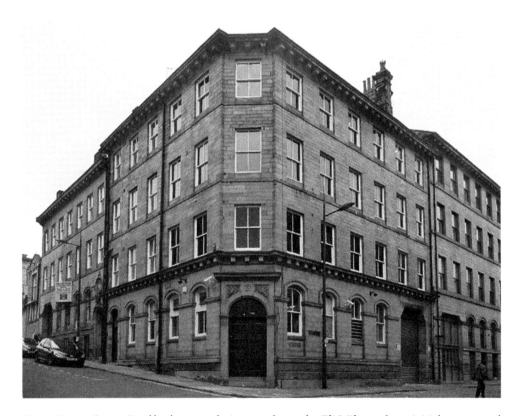

No. 8 Currer Street, Bradford, a speculative warehouse by Eli Milnes whose initials are carved above the door. Canted corner but very few frills. © Stephen Richards.

This building was owned and built by Eli Milnes, an eminent architect and astute businessman who built many of the warehouses in Little Germany. It housed the German stuff merchants Martin Hertz and Co. There is a sculptured monogram over the principal doorway with the inverted cornucopias spilling out the fruits of the earth.

Upon the sale of the Vicarage Estates he bought several plots of land from the Vicar of Bradford, the Rev.John Burnett. This speculative venture brought him rich rewards, not only in the resale of the land, but also in the building commissions that followed. He bought this warehouse site of 489 square yards for £489 and sold a major interest to James Wilman, landlord of the Craven Heifer in Girlington, for £1,600.

Stuff Warehouse, No. 13 Currer Street, by Hope & Jardine

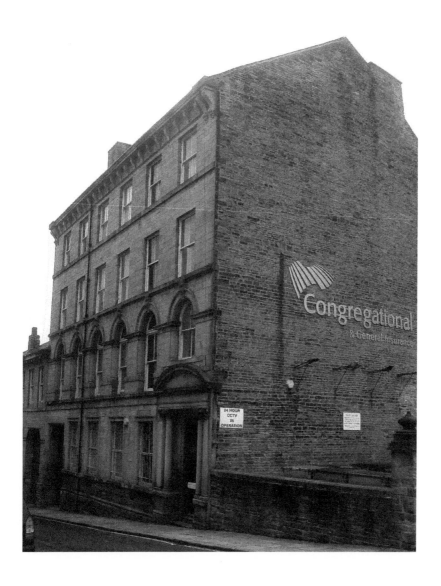

This is an export warehouse of six bays with wider than average windows and restrained but scholarly detailing. The most noteworthy feature is the magnificent millstone grit surround to the loading entrance which comprises a four-ton ornamental horizontal ashlar block matching vertical columns, the most striking example of gritstone masonry to be found in Bradford. There seems to be some mix-up as to the dates and owners of this building. It has been noted that in around 1871 this stuff warehouse was occupied by Wallace Marsden & Co., a little known local company, and by 1886 the premises were held by the German company Auerbach Erckermann. In 1912, this warehouse was occupied by a well-known Bradford printing firm, W. M. Berry Co. Ltd, where they continued to trade for fifty years. In the original layout of the area, the top end of Currer Street terminated in a cul-de-sac. This warehouse was the last in the street, the higher ground being occupied by domestic housing which faced onto Peckover Street. These two streets were not linked together, until the end of the First World War.

Hospital Fund Building, No. 72 Vicar Lane, by Eli Milnes, *c.* 1860

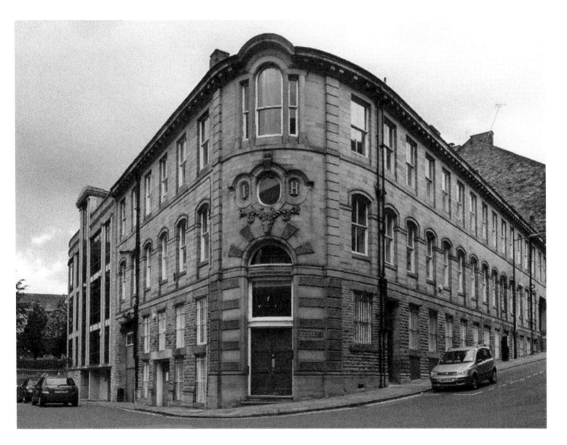

© Stephen Richards

An interesting design feature on this building is the beautifully-carved stag's head set above an exotic ensemble of ornamental stonework over the main entrance; the meaning of the sculptured initials I. H. remains unexplained. Also, a 10-foot wrought-iron girder supports the overlying wall and reduces the wide loading entrance, a standard Victorian method of spanning a wide opening.

This is one of Little Germany's smaller three-storey warehouses. The first recorded occupier was a stuff merchant, L. Lewis & Co. in 1870. Little further is known about the occupants until 1886, when it was taken over by Firth Marshall Ltd and then, in 1900, by Philipp Falkenstein & Co. In 1928 Edward Albert Lassen, recorded as a stuff merchant, was operating from this building, but business might not have gone well, as he was mentioned in connection with a bankruptcy receiving order in November 1928.

In 1965 The Bradford Hospitals Fund transferred to this building.

Stuff Warehouse, Nos 68–70 Vicar Lane corner with No. 6 Currer Street, *c.* 1857–58

An interesting feature in the construction of the building is the use of Park Spring Stone from the Leeds quarries, instead of using the local Bradford stone. Another detail is the quadrant corner of this building whereby the canted corner became more popular around 1852. In 1857 the Reverend John Burnett, Vicar of Bradford, indentured this plot of land to a Manchester based merchant, James Reiss, and his sons James Edward and Julius Adolphus. James Reiss was born in Frankfurt in 1812, arrived in England in 1833 aged twenty-one and became a naturalized subject in 1845. He formed a partnership with his brother Leopold and they established themselves as stuff merchants in the cotton boom town of Manchester. In 1837 they opened an office in Leeds and in 1863 transferred their mercantile headquarters to Bradford. Victor Sylvester Sichel, father of the famous painter Ernest Sichel, was the manager of the wool merchants Reiss Bros.

Downs Coulter's Warehouse, No. 4 Currer Street, by Andrews & Delauney, 1859 with fronts to Field Street and Vicar Lane

This warehouse was built, for Nathan Reichenheim & Co., although plans for this building were drawn for N. H. Heydemann. Heydemann was agent and manager for the international firm of stuff merchants, Nathan Reichenheim Sons & Co., whose headquarters were in Berlin and whose elaborate monogram can be admired above the main entrance. Up to the turn of the century, the Bradford branch of Reichenheim was a major exporter of yarn for John Foster of Queensbury until they began spinning and manufacturing on their own account. In 1900 the Reichenheim company ceased trading, the business being transferred to their Bradford manager, N. H. Heydermann, who continued business as an export yarn merchant for a further seventeen years. One of the many other duties appointed to Heydermann was that of acting German Consul to Bradford in 1893.

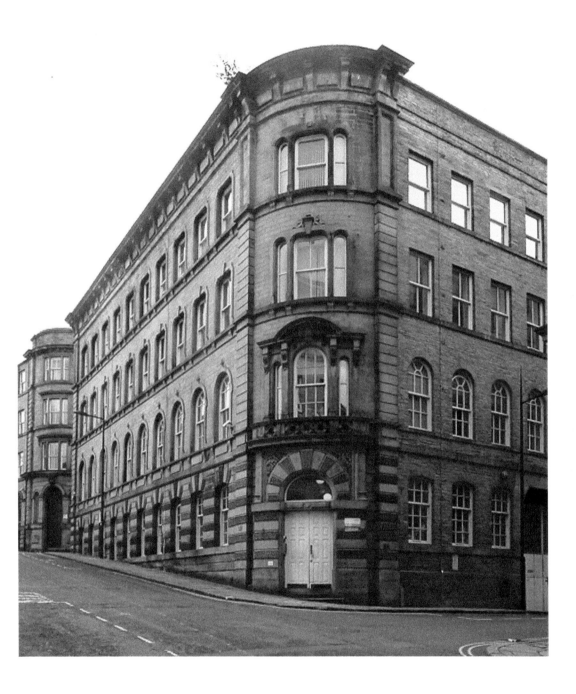

Further plans were drawn as an extension at the corner of Currer Street and Vicar Lane for Messrs Reichenheim, by Andrews Son & Pepper in 1866. In 1917 the warehouse was purchased by Downs Coulter & Co. Ltd, lining manufacturers.

The company commenced business at Pudsey in 1893 and later acquired further mills at Wilsden and Thornton, plus a cotton mill in Chorley. They developed their

Downs, Coulter & Co. Ltd.

Telegraphic Address:
"LININGS, BRADFORD."

Code :
A B C (5th Edition),
used for cabling.

Telephone :
No. 1015 BRADFORD.

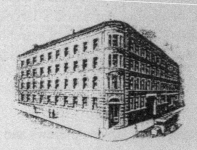

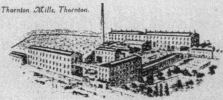

Thornton Mills, Thornton.

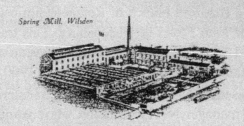

Spring Mill, Wilsden

Manufactures :

Mohair Linings in
Beatrice, Serge,
Princess, Victoria,
Mabel, Emperor,
&c.
Worsted Italian
Cloths.
Cotton Italians &
Cotton Twills in
Beatrice, Serge,
Princess, Victoria,
Mabel, Emperor,
&c.
Cotton Venetians in
Marquise Finish &
Marquise - de - luxe.
All Wool & Union
Serges, Gabar-
dines, &c.
Cotton Coatings &
Trouserings.

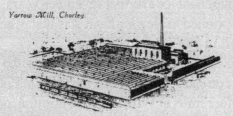

Yarrow Mill, Chorley.

Registered Office
and Warehouse : **4, Currer St., BRADFORD**
WHERE ALL COMMUNICATIONS SHOULD BE ADDRESSED.

Reproduced from the *Chamber of Commerce Year Book 1919*

own shipping trade and became the largest manufacturer of linings in Great Britain. Due to lack of space and modern operating facilities they vacated the Currer Street branch and transferred to their larger premises to Thornton.

The Reichenheim warehouse was occasionally used for wool storage until March 1986 when a section of the upper storey suffered from fire damage. The building was rebuilt in the 1990s and converted to residential accommodation – the first residential conversion in Little Germany.

Stuff & Wool Warehouse, No. 47 Well Street, by Andrews & Delauney, 1855

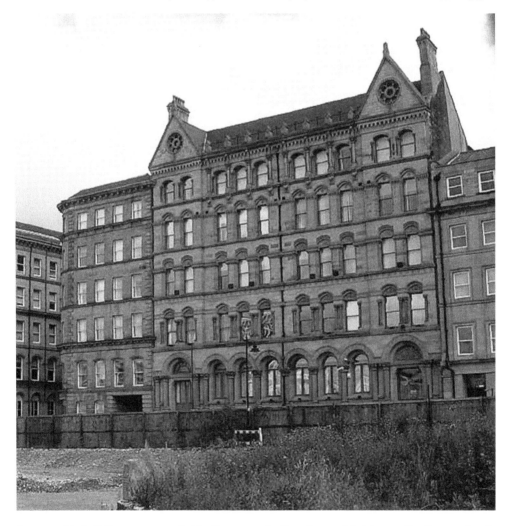

In 1898 this building was occupied by Rogerson & Co., the world's biggest distributor of soda treated cotton. © Betty Longbottom.

This tall and impressive warehouse palazzo, on the corner site with Currer Street and extending back to Field Street, was the first warehouse to be built and standardized the height of all future development in Well Street. The building was constructed to serve two functions. The block facing Well Street was designed as a stuff warehouse, the building at the rear was purpose-built as a wool warehouse (note the hoist and taking-in doors) at a time when wool warehousing was at a premium.

Like many others in Little Germany, this building served as premises for many companies. The earliest recorded tenancy was that in 1863 of Carlton Walker Watson, stuff merchants. In 1891 the premises were jointly occupied by J. Brooke & Co and Broadbent & Son, both trading as stuff merchants. Situated on the wall of the building facing Well Street is a Heritage Trail Plaque, recording that in 1898 this building was occupied by William Rogerson & Co. who, taking advantage of current developments in cotton finishing in Bradford, became the world's largest distributors of mercerized cotton poplin. In 1886 the wool warehouse section of the building was occupied by A. Jacobs & Co., loosely described as a merchant.

No. 45 Well Street, includes No. 1A Currer Street, by Eli Milnes, 1864

This large warehouse is a matched link, apart from a few minor details, with neighbouring buildings on Well Street. Similar to Nos 39, 41 and 43 Well Street, it is built of sandstone with fine quality ashlar dressings. Palazzo details are rather more

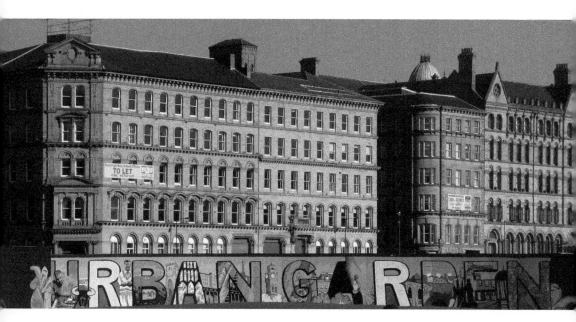

Left: No. 39 Well Street, Centre Left: No. 45 Well Street, Right: No. 47 Well Street, Far right: Nos 51–53 Well Street.

ornate on Nos 39 and 43. These are five-storey buildings with semi-basements and similar elevations, but they are somewhat plainer than neighbouring buildings.

Henry Heymann and Albert Alexander were German export stuff merchants. However, these partners did not reside in the area, the Bradford branch being managed by E. S. Lassen. Albert Edward Lassen and his father Edward Samuel Lassen were, for a time, in partnership with Albert Heymann, William Henry Heymann, and Albert Bernhard Alexander. They are recorded as 'carrying on business as merchants at Bradford, in the county of York, and at the city of Hamburg, under the style or firm of Heymann and Alexander.'

In 1900 Albert William Lasson, the father of Edward Lassen, was appointed Austro-Hungarian Vice-Consul in Bradford; the consulate also occupied one of the rooms in this building.

Close-up of carved and incised detail to this building. The columns are pink granite. © Stephen Richards.

Pennine House, No. 39 Well Street/Church Bank, by Milnes & France, 1867

39 Well Street, now known as Pennine House, is one of Little Germany's larger warehouses. The building has a canted corner to Church Bank, with incised pilasters flanking each floor. The staircase lies behind the canted corner and rises in an octagonal well with ornate cast iron banisters and boldly modelled plaster panels on the walls. The main double doors are not hung but slide in grooves.

A record in the memorial register of deeds at the Wakefield Archives states that in 1865 the plot of land upon which this building stands was sold by John Douglas Esq. of Scarborough, to Paul Nathen Hardy of Manchester and Ludwig Nathen of Bradford. The deed also refers to Jonas and William Foster of Queensbury assisting with the purchase. The warehouse was known as Nathens Buildings. The company, Hardy Nathen and Sons, were commission agents and exported much of Foster's yarn (W. E. Forster woollen manufacturer and MP for Bradford in 1861) to German markets. At that time they were one of the world's leading importers of British wool yarns. In 1898 the newly-formed Bradford Dyers Association Ltd took over the building as their head office, sample rooms and administration centre. The BDA became the largest commission dyeing and finishing company in the world. In 1964 the premises were acquired by the Carrington Viyella group and then in 1971 bought by the Land and House Property Corporation Ltd of Frinton-on-Sea. The building is now vacant, awaiting a new future.

General Post Office Forster Square, by Sir Henry Tanner, 1887

Another of Bradford's majestic buildings is the former General Post Office at Forster Square, now known as St Peter's House. The contractors, J & W Beanland of Harris Street, were responsible for a vast range of important buildings throughout Britain over a period of forty years. The Government purchased the site at a cost of £37,650 but a period of almost three years elapsed before the building was completed due to bad weather and a lengthy building strike. When opened on 1 September 1887 the Post Office provided the focal point of the newly-completed Forster Square and represented the high quality of Victorian town planning in Bradford. Eight days after the opening, as a result of the stress entailed by this contract, William Beanland, the senior partner in the firm, died suddenly.

The building is classic in character and firm and solid in design, which prevents it from being overwhelming or oppressive. All of the stone in the frontage was obtained from Bolton Wood quarries. The building is now home to the Asian Arts group Kala Sangam.

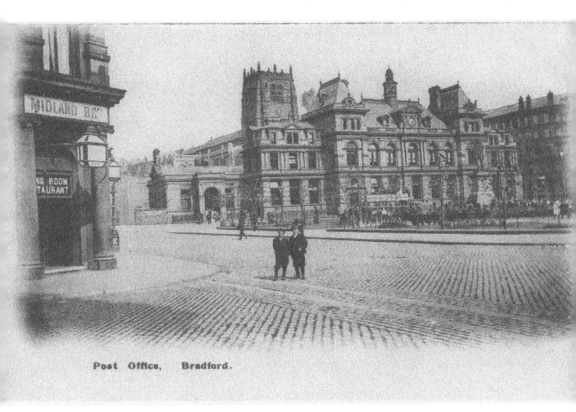

Post Office, Bradford.

© Stephen Richards.

St George's Hall, Bridge Street

One of the city's grandest classical buildings was built *c.* 1851–53 to the designs of Lockwood & Mawson who won the building competition. *The Bradford Observer* reported on the opening of the St George's Hall in their 1 September 1853 edition:

> The erection of public edifices is a natural result of the growth of large towns. First the commercial, then the municipal necessities of the town induce their erection and last of all, the social. Seventy years ago, when the inhabitants of Bradford became enterprising men of business, they found it necessary to erect a Piece Hall, to facilitate the operations of trade. Although their business was increasing and their profits pretty good, they had no superfluous capital and so they built their Piece Hall in the plainest and most inexpensive manner they could. This building served its purpose for some years, but eventually it ceased to be of use for the purpose it was erected and new modes of conducting business arose and superseded the Piece Hall, at this moment the old building is undergoing great alterations in order to adapt it for a retail trade.

St George's Hall is still Bradford's leading concert venue. J. B. Priestly was moved to

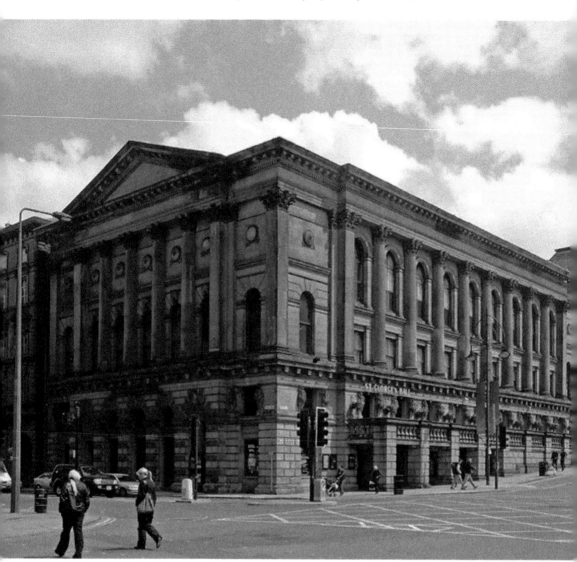

note that 'the strong musical tradition in Bradford owed much too Jewish support'. It was built as a public hall for notable speakers and performers, and also as a concert hall which played host to music hall performances too. The hall opened on the 29 August 1853 with seating for over 3,000 people, although today it seats a more modest, but not insubstantial 1,500 people.

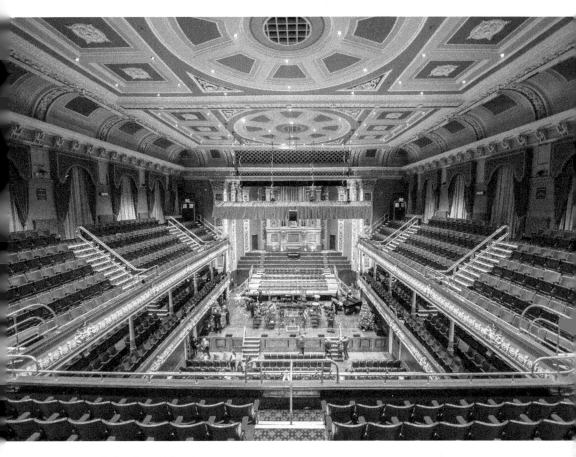

Opposite: © Stephen Richards.

Above: The interior of St George's Hall, Bradford. Musicians prepare for a rehearsal of the evening's concert, which opened the Delius Inspired Festival with the BBC Philharmonic Orchestra, the Leeds Festival Chorus and Sheffield Philharmonic Chorus. The programme included the Violin Concerto and Sea Drift by Delius.[6] © Copyright Rich Tea.

CHAPTER 7

POLITICS, TRADE AND THE START OF A LONG DECLINE IN THE WOOL TRADE

Throughout the past 200 years, the wool trade in Bradford has suffered a number of crises. There was a near-collapse in 1850 due to the insufficient supply of raw material, rising wages and attendant high prices. This was the cause of growing trade deficits, Great Britain being predominantly an importer of raw material and exporter of manufactured articles. Diminishing profit margins caused fewer investments which spread to other trades, finally reaching basic industries such as iron and coal. There was also a decrease in government spending, following the Crimean War.

In 1851 the Great Exhibition was held at Crystal Palace and Bradford's worsted manufacturers were well represented. An observer made the following comment,

> The most remarkable exhibition [...] referring to alpaca and mohair goods, or mixtures of these with cotton and silk; the trade in which has sprung up within a comparatively short period and progressed with rapidity and success unparalleled in the history of manufactures. One town alone, Bradford, has risen from the obscurity of a mere manufacturing village to the position of one of the busiest and wealthiest communities in the country.

Labour costs were also weighing heavily on wool producers, considering the labour-intensive nature of bringing wool to market. This went through thirty-four processes, greatly more than required by any other textile manufacture. It might well be assumed that maintaining livestock and the treatment of wool had become increasingly expensive.

Slight relief was afforded to those in the woollen trade who were fortunate enough to obtain military contracts during the Crimean War 1853–56; especially those who manufactured 'the lower and coarser kinds of goods'. Because of the war, investment had floundered, production diminished and only about 25 per cent of manufacturing machinery was in operation. After 1856, when the countries of Europe had reverted to peace, there were periods of boom and bust and the price of wool and the cost of labour played a significant role in the economy during the following decade.

During the 1870s, a period of stagnation began to affect Britain's economy once more, this time due to competition from French manufacturers. Women's fashion was

changing and French designs and materials were becoming fashionable. After the Paris Exhibition in 1878 it became obvious that, instead of clothing made from the usual worsted black wool cloth, softer and smoother dress fabrics were suddenly in demand. This had an adverse effect on the Bradford trade. Also, new tariffs had effectively closed US markets to Lister's fabrics of silks and velveteen. Tariffs or taxes on foreign imports were a form of protectionism, introduced by governments to lessen the impact of the global economic decline by trying to boost national economies.

A long needed School of Design had been proposed by several leading Bradford personalities but little had been done to implement these proposals until 1877 when the Bradford Chamber of Commerce financed the building of a technical school offering instruction in modern textile design and manufacturing skills.

Towards the end of the century many stuff merchants were forced to diversify and start trading in semi-manufactured goods such as yarn, tops and noils and wool. Continental competitors, who originally had been customers, were now manufacturing their own finished pieces on looms often more technically advanced than their contemporaries in Bradford. The growth in world demand for these new dress fabrics presented a serious threat to the established manufacturers of the harder, mixed-fibre luster fabrics which had brought Bradford wealth. The trend was wholly ignored by producers and few attempts were made to counter the French supremacy in the manufacture of improved-quality products. In an endeavour to produce a softer yarn, several firms sought to change their method of spinning. The majority, however, did little to change their production techniques, believing that the old makes and styles of cloth would always be in demand. Because things had been so good for so long there was a great deal of complacency and firms were slow to invest in new machinery to maintain their competitiveness. Other countries were beginning to develop their own textile industries. In order to remain competitive, Bradford manufacturers cut labour costs which caused a great deal of unrest, especially at Manningham Mills which was owned by Samuel Lister, one of the largest factories of its kind in the world.

On 9 December 1890, Lister posted a notice outlining reductions in pay for weavers, pickers, spoolers and winders, hitting 1,100 workers in total. This 25 per cent reduction of 1,100 worker's wages in the velvet department, caused by a tariff placed on imported velvet by American President McKinley, was a key event which had national repercussions. Samuel Lister claimed that his workers had been paid 'unnaturally high wages'. He argued that when Britain dominated the world market in textiles the employer could afford to pay better wages but with a much weaker world economy, workers must accept more 'realistic' wages. Manningham Mills, being the largest silk factory in the world, had previously enjoyed a virtual monopoly on velvets and plushes and Lister was the biggest employer of labour in Bradford at that time. In 1884 over 4,000 men and women were employed at his mill and by 1890 the figure had risen to more than 5,000 workers. Lister himself had become immensely rich and although he boasted about having done more for his workers and the prosperity of Bradford, in 1890 he set about reducing the wages for his 1,100 workers. This was to come into effect on Christmas Eve and as an extra token of 'goodwill', he threatened that in case of revolt he would lock out his workers.

The strike, which ran for nineteen weeks between December 1890 and April 1891, was spurred on by Lister's refusal to negotiate, despite having made a profit of £138,000 (about £27 million today) and paid a dividend of 10 per cent to shareholders in the previous year. This stance was a bridge too far. Unions and societies representing workers in other industries and occupations across the West Riding established a fund to support the striking workforce at Manningham Mills. The campaign also attracted support from the middle classes, including W. P. Byles, editor of the *Bradford Observer*. Although he was a Manningham resident and shareholder in Lister and Co. he advocated a smaller dividend in return for better wages for millworkers.

There was picketing at the mills and regular processions to raise awareness. Between 10,000 and 20,000 people attended meetings, while the strike's final meeting in Bradford city centre attracted huge crowds. By this time nearly 5,000 employees at Manningham Mills were either on strike or locked out and it was the scale of the strike which placed a strain on strike funds. The press mostly showed a good deal of sympathy with the workers. Throughout January and February 1891 the number of workers out had grown steadily. Over £1,000 per week was needed to sustain them through a particularly hard winter, with heavy snowfalls as late as mid-March. Although there was a great deal of suffering among them, this strike became a national issue – a fight between capital and labour – 'the classes against the masses.' Public meetings were generally forbidden until permission was grudgingly given for a meeting to be held at St George's Hall. Violent clashes grew into riots, which led to military support being called in. The riots were repeated the following night and again troops with fixed bayonets were called upon to disperse the crowds estimated between 60,000 and 90,000 people.

Despite widespread support, the strike was beginning to crumble through lack of funds, and many families were on the brink of starvation. On 27 April 1891 the great Manningham Mills strike of Bradford textile workers ended after nearly nineteen weeks and the employees of Lister and Co. returned to work on reduced wages. The strike had vividly highlighted the clash of interests between capital and labour and disclosed the Liberal Party's failure as a vehicle for Britain's working class. The struggle became a marker for young socialists emerging in the trade union movement who were searching for a party to represent the interests of the working class.

CHAPTER 8

THE GERMAN PORK BUTCHERS

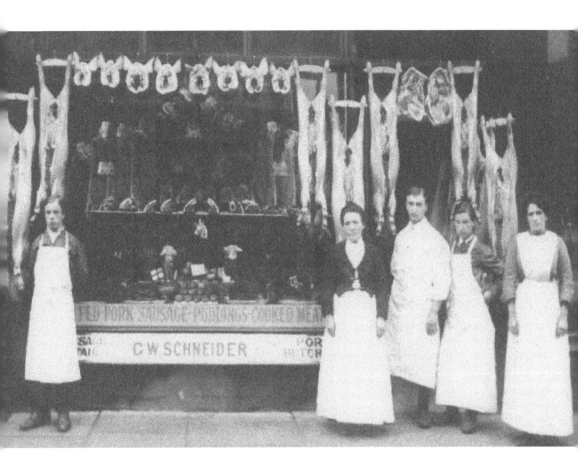

The German pork butchers who came to Great Britain from the beginning of the nineteenth century until the First World War, originated from Hohenlohe, a small agricultural-based region in the north-eastern corner of Baden-Württemberg in south Germany. This comparatively small area covers a radius of approximately 30 miles.

Historical documents, researched by the historian Karl-Heinz Wüstner, prove that family names and villages connected with this group of German migrants were situated

in this comparatively small region. Emigration details in local archives show not only a mainstream of emigration to North America, but a surprisingly large number of emigrants from this area chose England as their land of opportunity. This was probably due to the fact that Great Britain was closer to their homeland and also that settlement in Great Britain's rapidly-developing industrial society was comparatively straightforward, with plenty of opportunity for those willing to work hard.

The Hohenlohe area in Baden-Württemberg in south Germany surrounding the small town of Kunzelsau had often been subject to agricultural depression due to crop failures. Also, the traditional inheritance of farms and smallholdings being taken over by one child of a family only, who in most cases was the most skilful son or even a son-in-law, left siblings to find work as farmhands. During the winter months they sought the opportunity to train as butchers and these excellent skills and abilities enabled them to find work as pork butchers.

Their pattern of emigration shows three distinct phases at that time and the first of these groups were professional butchers who initially settled in Britain in the early nineteenth century. In Sheffield their numbers 'grew from just one in 1817 to fourteen in 1883 and eighteen in 1914'.[1] Once established they showcased their prosperity and the growing opportunities for success. The demand for pork butchers in Britain increased noticeably, but the number of qualified Hohenlohe butchers who could follow the call dwindled considerable. Therefore, many young sons of farmers were ready and able to take up the challenge.[2] Hohenlohe butchers moved to the industrial areas of northern England, like Sheffield, Bradford, Leeds, and Manchester and later to port cities such as Hull and Liverpool.[3] They also opened countless butchers' shops in London and having originally come from a close knit community, started to settle further apart.

As they often didn't speak English very well integration into British society was achieved step-by-step. Nevertheless, German pork butchers were well liked and respected by their customers. Some of these pioneers married into British families, or posted letters home that requested young women for household duties, or for marriage as well. They were well equipped with food preparation knowledge, as well as a rich fund of delightful, secret and family-kept recipes. When slaughtering at home 'their mothers [...] would have salted, smoked and pickled some of the meat for the winter months.'[4] Many married into each other's families, establishing a real and efficient migrant business network. Germans in Hohenlohe would also send their older children after leaving school to a family member or friends in England, in order to learn the trade and set up their own butchers' shops. New arrivals would be regularly welcomed at London or at Hull harbour.

During the second-half of the nineteenth century they had already spread further afield, setting up numerous shops in smaller villages until there was hardly a town that didn't have a local German pork butcher. At that time, British butchers dealt mostly in lamb, mutton and beef.[5] Their success was based on industrialization and rapid growth of population during this urban boom. Long working hours and steady wages of factory workers had created a market for fast, cheap and tasty food. This was a market that these entrepreneurs, with a cultural background in producing pork

products, could service – even to the extent of serving convenient, hot food after the factory had closed.[6] One might claim them to have been the first sellers of 'take-away' food, readily accepted by English factory workers who had no time to cook or had never been taught to cook from mothers who had also worked long hours.[7]

The shop-window display was considered vitally important and became almost an art form. Bacon was presented on porcelain dishes and it was one man's job to keep them filled. Additionally, the shops would keep ham-water boiling, offering an appetizing aroma to all. Completing the picture, fifteen to twenty sides of pork were hung on display in the various shop fronts, hitherto unfamiliar in Great Britain.[8] Thus, German pork butchers formed a close-knit network of family enterprises and trades. They made a good living, successfully filling the market-niche they had discovered. Some amassed large fortunes that either secured them a respectable place in British society, or enabled them to build large English style houses back home in Hohenlohe.

What were the main products that pleased the customers so much? Provided is the answer, given by Louis Schonhut, a descendant of a Hohenlohe cabinet maker family of the nineteenth century. He writes, 'Pork butchers sold many different kinds of sausages like polony, black and white puddings, haslet, jellied brawn, pork pies, chitterlings and all kinds of cooked meats now scarcely known to the present generation. These were made in their hundreds each week.'

CHAPTER 9

WHAT HAPPENED TO THE GERMANS?

… and obscurely felt that they had always been with us and would always remain.
J. P. Priestley, *An English Journey*.

In 1889, the Select Committee on Emigration and Immigration reported concerns about the growing size of the German population in Britain, alarmed by the strengthening of German forces and the erratic behaviour of the German Emperor. It seemed certain that Wilhelm II was planning to strengthen his power and although his mother, being the eldest daughter of Queen Victoria, was British (it has been claimed that William II hated his mother), his eccentric views on foreign affairs were a growing cause for alarm.

However, opinions obviously differed regarding the British attitude towards Germans at that time. An article entitled 'Bradford's German Yarn Trade' in the *Yorkshire Post* of 14 November 1901, praises the 'little colony of natives from the Fatherland' referring to the achievements of German wool merchants in Bradford; the practical character of their enterprise and education being equal to none. The article gives an account of growth in the wool trade and the Germans' contribution towards its success by purchasing yarns in Bradford and exported them mostly to Germany. However, the unknown author did point out that the machinery for the treatment of wool, purchased in Great Britain and exported to Germany, was now being manufactured there and competing with British products.

In 1903, the Royal Commission on Alien Immigration described fears about the lives and actions of Germans in England, especially fear of crime and the stereotypical 'German swindler'. German-born governesses, musicians, tailors, and waiters were particularly targeted as supposed infiltrators. German clerks were also targeted as a result of 'spy fever' because they sometimes had access to sensitive business materials. Panikos Panayi describes the four main sources of hostility against Germans before the outbreak of the First World War as being caused by fears that Germany was threatening Britain's global dominance and the growth of German naval and military strength. The four main sources were:

Stereotype negative characteristics created through literature, journalism, and scholarly research.

Hostility towards poorer immigrants.

Discrimination against individual trades dominated by Germans.

Political hostility and the decline of Anglo-German relations from the 1870s onwards.[1]

As German armies rapidly advanced through Belgium, mobs attacked Germans and their property throughout London and many industrial cities. Although 'Anglo-Saxonism' had emphasized the common heritage and Germans had been well accepted within the community (e.g. German pork butchers), a new resentment had now developed and 'Germanophobia' expressed increased hostility towards all things German in Britain. Paranoia was so prominent that it was feared that British ports had been overrun with German spies and trained soldiers. On August 4 1914 Britain declared war on Germany, and the next day Parliament passed the Aliens Restriction Act, transforming every foreigner born in Germany or Austria-Hungary into an 'enemy alien'. This allowed the British Government to control the movement of people classified as such. All citizens of the German Empire were classified as enemy aliens, while all other foreigners were classified as alien friends. People classified as no aliens were permitted to enter or leave Britain at will. German subjects had to register themselves at the nearest police station. British women who had married Germans and thus become German citizens, must also be registered. The children of such marriages were in a similar position. Foreigners desirous to leave would find no difficulty, unless German subjects, if they provided themselves with passports etc., and made sure beforehand of train and boat services. Permits were only given to leave Britain by certain ports on a given date by a given steamship service.[2]

Those who remained were required to register at their local police station. In cases of denial, they were arrested and taken to court. This was an agonizing situation for the British-born wives and children of Germans who had automatically gained German citizenship through marriage, and those who had lived in England for many years. Under the terms of the 1870 Naturalisation Act, any British woman marrying a foreigner automatically lost her citizenship and, in the eyes of the government, took her husband's nationality, even if she was later widowed or separated. If a German-born man took British citizenship, then his British-born wife could be issued with a certificate to confirm her new status – as a Briton. By November 1914, wives were also required to register and suddenly, hundreds of women and children who had been born and raised in Yorkshire found themselves aliens in their own homes.

Advice to Aliens now in Britain was issued by the British Government as below:[3]

Under the orders of the Home Secretary, German and Austrian subjects living in Britain are given until 10 August to leave and any German remaining after that date is required to register at the local police station by 17 August, Austrians by the 23rd, or face a possible £100 fine or six months imprisonment.

Long queues of businessmen, nannies, students, tourists stranded by the war, and old men and women who had left their homeland as children, formed and stood patiently for hours before being processed. Both the British and German governments

agreed to repatriate women, children, elderly men and ministers and even finance the transport of any who could not afford the fare. It is estimated that by December 1914, approximately 7,000 women and children had left Britain.

Over the weekend quite a number of young Germans residing in Bradford left the city in order to re-join their regiments. Yesterday about thirty departed for London on the 2.50 p.m. train. They were seen off by friends and the German pastor.[4]

The following news item appeared in the *Bradford Daily Telegraph* of 20 August 1914,

The Bradford registration of aliens is now complete and shows a larger proportion of Germans and Austrians within our city than many people might imagine. Many of these occupy important positions in our commercial life and may be regarded as friendly. They will have no use of a telephone or motor car and all their correspondence is subject to careful scrutiny. They are not allowed to leave town without a police permit.

Meanwhile, after the German reservists left Bradford for their homeland, other young men with German names like Muller, Hamlin, von Hallé and Bernhardt were seen off from the same Bradford station on 20 August by the Mayor and Chief Constable as they set out for officer training in the British Army.

Norman Muller, from Cononley near Keighley, would die leading his troops into battle in 1918. He was the son of Colonel George Herbert Muller, the first commander of the 'Bradford Pals' (a locally-raised battalions of the British Army) and himself the son of a German immigrant.[5]

For the children of non-naturalised Germans, options for military service were limited. Most were placed in a special labour corps in the Middlesex Regiment by the War Office under issue ACE 1209. The theory was that they might hesitate to fire on the front line, or mutiny. The sons of pork butchers were involved in supplying food to the troops and keeping them off the frontline, this did mean that few fatalities were suffered among the families of non-naturalised pork butchers.

Although some Britons of German descent might have been willing to serve their adopted country, there were many more whose loyalty was in doubt. Police and army patrols were sent to round up German males deemed to present a threat to national security. It was not always clear what threat someone posed. Temporarily held in police stations and army camps, these civilian internees were released back to their families if the local Chief Constable was satisfied they did not present a risk, although they would not be allowed to use telephones, their correspondence was subject to censorship and they would require special permits to travel more than 5 miles from their homes.

On 7 May 1915, the RMS *Lusitania*, a passenger ship belonging to the British Cunard Line sailing from New York to Liverpool, was sunk by a submarine belonging to the German Marine off the coast of Ireland, killing 1,197 civilian passengers. This caused an unprecedented public outcry and the first riots occurred in Liverpool the following day. Much of the *Lusitania* crew was from Liverpool, so it is not surprising that it was one of the first towns to react towards German communities. The *Manchester*

Guardian stated that 'working men could not be expected to work beside Germans who were sniggering and laughing, congratulating themselves upon the great tragedy that happened last week'. The Smithfield Market in London declared a boycott of all Germans, naturalized or not, making it likely their business would have to shut down.

Riots and vandalism spread around the country. The premises of German shop owners were damaged and their owners attacked; shop windows were smashed and products stolen from their shops. Their owners suffered greatly from this intolerance, even at the hands of their previous customers. This resulted in the declaration that 'all adult males who were non-naturalised Germans should, for their own safety and that of the community, be segregated and interned, or, if over military age, repatriated.'

As often is the case, the English press played a leading part in sustaining the rapidly developing prejudice against 'the Germans' and anything or anybody considered to be remotely aligned with 'the enemy'. The reaction to this was so terrible that Germans

in Bradford presented the town mayor with a signed protest, reported in a number of national newspapers. Here is a copy of the article in the *Liverpool Daily Post* on 12 May 1915, titled 'German Horror at German Inhumanity':

> Last night a deputation, consisting of the leading commercial men of German birth in Bradford, waited on the Lord Mayor of that city and signed a written protest, which read as follows: 'We men of German birth who have adopted Great Britain as our home and are naturalized British subjects protest in the strongest possible terms against the inhuman manner in which the German Government has waged war against non-combatants including women and children, culminating in the sinking of the *Lusitania*. We wish hereby to place on record our horror and indignation at the outrages'.
>
> The following day, it was reported that the number of German protesters against the German government had risen to eighty-three.
>
> In the initial days of the internment operation, riots continued when people saw that the police did not intern all aliens. German shops were still being continually vandalised and robbed, especially the pork butchers, some of whom had sons fighting in the war. Often when home on leave they would serve the customers dressed in their uniform to shame the people who had expressed ill-feeling towards their families. During the period following the sinking of the *Lusitania*, repatriation efforts were increased and nearly 10,000 persons left the country. No policy was created until 1917 for the repatriation of men, for fear that many would join enemy forces.

Contrary to historical research relating to other areas in Great Britain, to a large extent Germans in Bradford managed to avoid the extreme violence suffered by their compatriots in other parts of the country. It seems that many members of the German-born population in Bradford were still highly respected despite the war and there is little doubt that this can be accredited to the philanthropic activities of a few German wool merchants. Also it must be taken into account that two members of this honourable society, Jacob Moser and Charles Joseph Semon, had served terms as Lord Mayor of Bradford. Jacob Moser from 1910 to 1911 and Charles Semon in 1864. This could also be one of the reasons why animosity towards German-born Bradfordians was kept within a limit during the war.

Newspaper reports of such atrocities in Bradford were few and probably the result of alcohol excess, as in the following article in the *Yorkshire Evening Post*, dated Monday 31 May 1915.

Margaret Bligh describes the experiences of her German-born father in her book, *Dr Eurich of Bradford*, 'Moods of excitement and exaltation alternated with bitterness and hatred, and in Bradford the large ex-German population provided an immediate scapegoat for an overwrought people. At this distance of time, it is possible to view these psychological phenomena clearly and dispassionately, and, as Dr Eurich would have said, "To make allowances".'

In her book, she also describes his return to Bradford from a month's holiday at St Anne's-on-Sea and the absurd rumours which had already spread that Dr Eurich was serving in the German Army Medical Corps and Mrs Eurich (whose health was frail and

BRADFORD MAGISTRATE AND ANTI-GERMAN VIOLENCE.

Herbert Parker (31), a woolcomber, of 647, Manchester Road, pleaded guilty at Bradford, to-day, to doing damage to the amount of £2 10s., to a plate-glass window, the property of Albert Schussler, a pork butcher, of 256, Manchester Road.

About 4 p.m. on Saturday, prisoner threw a parcel containing boots against the shop window, which had previously been broken, but of which there was a large portion intact. He was under the influence of drink, and was shouting "German spies." The prisoner expressed great regret at his conduct.

The Stipendiary Magistrate (Mr. Beaumont Morice), in sentencing the prisoner to a month's hard labour, said that this kind of thing must be stopped.

Mr. Schussler, though of German extraction, was born in this country.

who could not speak a word of German) was reported to be nursing at a war hospital in Strasbourg. Dr Eurich had then feared, after numerous rebuffs from colleagues, for his position on the Honorary Staff of the Bradford Royal Infirmary, despite being honoured for having discovered a method of destroying the deadly anthrax bacillus without damaging the bales of raw wool it had come in, thus preventing further outbursts of the dreaded 'Woolsorters Disease' and saving hundreds of lives.

Those detainees deemed a greater risk were sent to internment camps being set up around the country, including one of the most unusual prison camps established during the war – the Lofthouse Park Zivilinternierungslager (Civilian Internment Camp) in Wakefield. Built by the Yorkshire West Riding Electric Tramway Company and opened at Whitsuntide 1908, Lofthouse Park was Britain's first amusement park and had been created around a country house and its grounds. The camp had three sub-divisions. First to be created was the south camp around the concert hall which contained a stage and an auditorium and soon became a rabbit warren full of beds, chairs, clothes, and men. As the camp filled, some wooden huts were added along with a hospital and barracks block. Later, a north camp was built using rows of long, low, wooden huts and there was a corrugated iron hall presented by an Anglo-German donor. Finally, a west camp of corrugated iron huts was built on treeless and grassless waste ground adjoining the main camp. Each area was sealed and special permission was needed to move from one division to another. As a result, each developed its own character.

Paul Cohen-Portheim, a German artist who became entangled in British bureaucracy and interned while on holiday in England, spent most of the war at Lofthouse. He recalls in his book, *Time Stood Still: My Internment in England 1914–1918*, his experiences as a German civilian interned in England and describes how Lofthouse was divided into three sections:

> The South Camp housed men who had dealings in African colonies and were 'inclined to be cranky'. The North Camp was 'rigid and correct' and internees there regarded themselves as socially superior.' He himself lived in the West Camp which he describes as the most colourless and monotonous of the three and essentially middle class. 'Nearly all its inmates were business men who had lived in England before the war; a very few in a big way of business, but mostly men of moderate means. There was a majority of middle-aged and a minority of young men, mostly city clerks.

Lofthouse was considered to be a 'privilege' camp for which inmates had to pay 10s per week for the privilege of being held there, but conditions were at least tolerable and it is more than probable that many Germans settlers in Bradford were interned in Wakefield. A theatre group was established, men were able to attend classes in various subjects (although German academic establishments later refused to recognize the courses as had been hoped). Men were given garden plots to tend, musical instruments were provided and even an art studio was available. But even such luxuries did not

detract from the fact that the men were being held prisoner and forced to part from their families.

The two largest internment camps were located on the Isle of Man. About 30,000 prisoners were sent to the Douglas Camp on the east side of the island, and Knockaloe Camp on the west side. Many German prisoners were taken into custody from merchant ships and fishing trawlers; were arrested in Commonwealth countries and without much ado transported to Knockaloe where they remained for the duration of the war. Most accounts written by former detainees are surprisingly objective, describing the monotony of life behind barbed wire and the lack of privacy causing depression among prisoners. They were treated similarly to those in Lofthouse (Wakefield). Both prisons catered for wealthier middle-class refugees, but the consequences were extensive for both the men interned and their families left behind, as was the case for British civilians interned in Germany.

A closer examination of the *Bradford Trade Directory* from 1920 to 1921 shows that after the First World War a surprising number of about forty pork butchers were still doing business in the Bradford area, many in the second and even third generation.

The First World War was also an important turning point for the Jewish community of Bradford. Many changed their names or gave up Bradford altogether. This would appear to explain why no descendants of the German Jewish merchants can be traced in Bradford today. Although this might be an exaggeration, a large number (it was said half of Bradford) changed their German forenames and surnames. Victor Edelstein rebranded himself and his business as Victor Elston and his son Adolphus Julius, followed him into the business. The following announcement appeared in *The London Gazette*, 8 June 1915.

We, VICTOR EDELSTEIN of Oaklands, in the city of Bradford, Merchant, being a naturalized British subject since the year 1881 and ADOLPH JULIUS EDELSTEIN, of the same address, a Staff Captain in His Majesty's Royal Field Artillery, being a natural born British subject, hereby give notice that we have assumed and henceforth intend upon all occasions and at all times to sign and use and be called and known by the surname of

Elston only, in lieu of and in substitution for our present surname of Edelstein, and that such intended change or assumption of name is formally declared and evidenced by two deed polls, both dated the third day of June 1915, under our respective hands and seals, and which deed polls were enrolled in the Central Office of the Supreme Court of Judicature on the fifth instant. – Dated this fifth day of June, 1915.

The fate of the family Dietz of Liverpool can be made exemplary of what happened to some German pork butchers well into the second generation, who had settled in other

Opposite: Knockaloe Internment Camp. Close to the west coast of the Isle of Man, near the port of Peel, stands a plaque commemorating the presence of the Knockaloe Camp. This remains one of the few clues to the presence of thousands of prisoners, mostly Germans, who found themselves behind barbed wire in Britain during the First World War.

English cities. Christian Dietz had come to Britain in 1891 as a sixteen-year-old boy. In Liverpool he met a young German woman, Margaretha Albrecht, whom he married in 1901. Christian and Margaretha had four children. When the First World War broke out, Christian Dietz was interned in Stobs Camp in southern Scotland and his wife was sent back to Germany. With her four children, she found shelter with her brother in Schrozberg. In the camp Christian Dietz carved a mutton horn as a memento of his detention.

When Christian was released from imprisonment in 1919, he returned to Germany to re-join his wife and family. After the couple were reunited, another son named Rudolph Eric was born in 1921. For some time the family ran a general store in Langenburg, but Christian found it difficult to resettle in his home country. After eight years he returned to Liverpool with his oldest son and was able to establish another butcher's shop, to be re-joined in 1932 by the rest of his family who still regarded Liverpool as their home. They became naturalised British citizens and changed their name to Deane.

However, when the Second World War began in 1939, Rudolph Eric was called up by the British Army. It was then that they realized that the young man of eighteen years still had his German nationality and wasn't a British citizen. He was arrested immediately and sent to Knockaloe internment camp in the Isle of Man, thus suffering

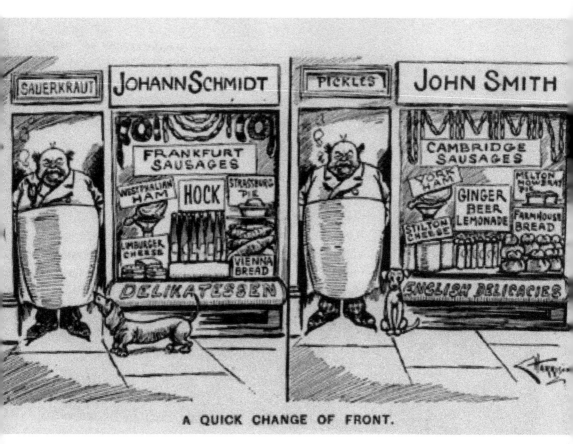

A QUICK CHANGE OF FRONT.

the same fate as his father, who had been interned by the British only twenty-years earlier.

Such are many similar cases of second-generation family members of German migrants being sent back to Germany at the beginning of the First World War, to a foreign country of which they had little knowledge, often ending in German prison camps suspected of spying. Shortly before the end of the First World War there appeared an article in the *Yorkshire Post* dated 27 August 1918, on behalf of The Aliens' Advisory Committee, referring to lists compiled of non-naturalised Germans in Great Britain. A representative of a London News Agency declared that some people did not understand the alien question and asked what one can do with a German who is eighty, ninety or 100 years old, considering that only somebody in a lunatic asylum – or possible the House of Commons – would think of interning such men. The list was finally divided into eight classes:

1. Technical aliens such as German colonies and Poles.
2. Germans over seventy or disabled by illness, of good character and record.
3. Not yet compiled, and may possibly be merged into the other sections.
4. Priests and 'ministers of religion', of which there were between forty and fifty.
5. Germans who came to England before they were ten years old, who have never been back to Germany and have nothing against them.
6. Germans who have sons voluntarily serving in HRM Forces and who themselves have nothing against them.
7. Germans of good character who have been in this country for thirty years, with English wives, or forty years, with alien wives.
8. All the remainder, chiefly consisting of Germans who are slightly under seventy, or who are slightly under the thirty-five to forty years residence qualifications.

Except in the case of Germans with bad records, it was not proposed to intern anyone over fifty-five years of age. The remainder would be liable to repatriation. It was therefore obvious that only a small proportion was of internable age and nothing very drastic in the way of internments was to be anticipated.

After the First World War, the pork butcher business never recovered, or became assimilated with British butchery, and the short but rich history of Hohenlohe butchers in Great Britain was practically at an end. The Second World War, with its re-emerging animosities against Germans and the reintroduction of internment, was the final death knell for the once-thriving pork butcher business that, for a long time, had been dominated by this enterprising group of people.

We know that most descendants of German wool merchants left Bradford during the decline of the wool industry. Some descendants of these successful merchants have, however, continued the tradition, such as the company of Sir Jacob Behrens & Sons Ltd. The company's Head Office is now Chepstow House, Manchester and the Bradford section is at Ravenscliffe Mills, Calverley, and Yorkshire.

Oswald Stroud (who was the son of Rabbi Strauss and unlike his father, changed his name to Stroud when in the army) started what became a successful textile business,

Stroud-Riley, which remained active in the export business until 1974 when the industry started to decline.

Despite international conflict, during the second-half of the nineteenth century a small but influential German community contributed significantly to Bradford's industry, its identity, physical landscape and culture. Although the textile industry declined in the twentieth century, Bradford has continued to receive different waves of immigrants from throughout the world. It has become a vibrant multicultural and multi-faith city.

NOTES

Chapter 1: Early History of Bradford
1. *The Story of Bradford*, Alan Hall.
2. British Wool Marketing Board http://www.iwto.org/wool/history-of-wool/
3. *The Story of Bradford*, Alan Hall.
4. http://bancroftsfromyorkshire.blogspot.co.uk
5. The Bradford Antiquary.
6. *The Story of Bradford*, Alan Hall.
7. An Investigation into Great Britain's Commercial Crisis of 1857 and the Preceding Business Cycle, John Henry Gendron, Providence College 2012.
8. *The Story of Bradford*, Alan Hall.
9. Worsted Textiles in Bradford – Information Sheet Factory Acts and Legislation.
10. Bradford Historical and Antiquarian Society, 'One Hundred Years of Local History', J. Reynolds and W. F. Baines, 1978.
11. *A Mercantile Meander*, Stanley Varo.

Chapter 2: The Wool Merchants
1. *Walking the Little Germany Trail*, John S. Roberts.
2. Ibid.

Chapter 3: German Migration to Bradford

1. *From Belsenberg to Britain: A Case* Study, Richard M. Ford.
2. *German Immigrants* in Britain, Panikos Panayi.
3. *German Immigrants in Britain during the nineteenth century 1815–1914*, Panikos Panayi.
4. *The Story of Bradford*, Alan Hall.
5. www.goldenroom.co.uk, (August, 2012).
6. *The Story of Bradford*, Alan Hall.

Chapter 4: The German Wool Merchants
1. *The Story of Bradford*, Alan Hall.

2. 'Making Their Mark', www.bradfordjewish.org.uk.

3. *Frederick Delius*, Sir Thomas Beecham, (1959).

4. Detail from Quatrefoil for Delius Rory Walsh © RGS-IBG Discovering Britain.

5. *Frederick Delius: Memories of my brother*, Clare Delius, (1935).

6. *The Short one on the Right: Letters from Eric Busby to his Grandchildren*, (1995).

7. With kind permission of the Bradford Synagogue, also with grateful thanks to Rabbi Walter Rothschild, Berlin.

8. With kind permission of the Bradford Synagogue, also with grateful thanks to Rabbi Walter Rothschild, Berlin.

9. *Telegraph and Argus*, (22 March 1941).

10. 'J. C. A. Dowse review of Dr Eurich of Bradford', Margaret Bligh, *British Medical Journal*, (Issue: June 10 1961).

Chapter 6: The Merchant Warehouses of Little Germany

1. *The Bradford Antiquary*, 'Building control in Bradford', Geoffrey Manuel.

2. www.bradford.gov.uk, Little Germany Conservation Area Assessment.

3. Ibid.

4. *Walking the Little Germany Trail*, John S. Roberts.

5. http://www.princes-regeneration.org/projects/eastbrook-hall-bradford.

6. 'Little Germany Conservation Area Assessment', www.bradford.gov.uk

Chapter 8: The German Pork Butchers

With grateful thanks to Karl-Heinz Wüstner for kindly allowing the use of his unpublished manuscript: *Lecture at Hinckley Island Hotel, Hinckley on 07.09.2013 on German Pork Butchers in Great Britain*, also for the following information: *New light on the German Pork Butchers in Britain*.

1. *Notes on Germans in Sheffield*, unpublished document, Gerald Newton, quoted in: Leslie Moch Page, p 105.

2. Helmut Megerle, from Söllbot in an interview with Karl-Heinz Wüstner in 2006 and Gerhard Ziegler, from Eckartshausen by oral information in March 2009.

3. Rosemary Winton, p 1 and Derek Bauer, p 36.

4. Louis Schonhut, in chapter 1.

5. *Newcastle Daily Journal*, (22 July 1897).

6. George A. Steele and Richard Ford, www.porkbutcherhub.org.uk, p 2

7. Robert Roberts, *The Classic Slum*, p 309.

8. Unpublished manuscript on the history of ASDA, p 35.

Chapter 9: What Happened to the Germans?

1. *German Immigrants in Britain During the Nineteenth Century*, 1815–1914, (Oxford: Berg Publishers Limited, 1995).

2. *Barnsley Chronicle*, (September 1914).

3. *Yorkshire's War: Voices of the First World War*, Tim Lynch.

4. Ibid.

5. Ibid.